The College History Series

BOSTON UNIVERSITY

D1560813

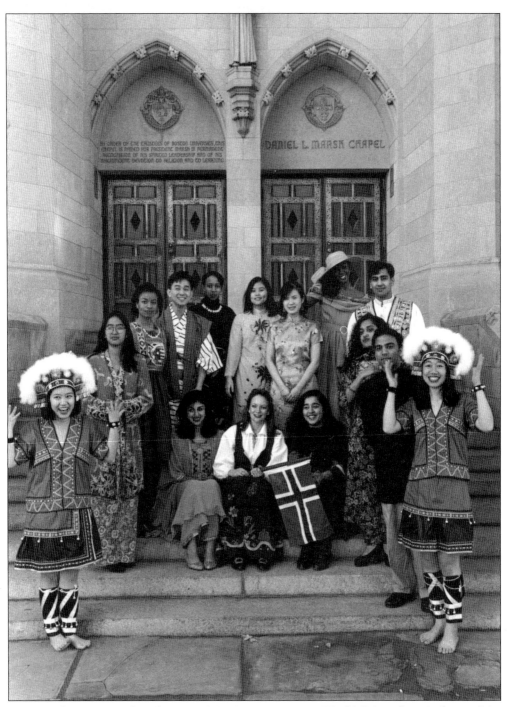

A group of international students participating in a campus World Fair gathers in front of the Daniel Marsh Chapel in March 1994.

The College History Series

BOSTON UNIVERSITY

SALLY ANN KYDD

ARCADIA

Published by Arcadia Publishing,
an imprint of Tempus Publishing, Inc.
2A Cumberland Street
Charleston, SC 29401

Printed in Great Britain.

Library of Congress Catalog Card Number: 2001098964

For all general information contact Arcadia Publishing at:
Telephone 843-853-2070
Fax 843-853-0044
E-Mail sales@arcadiapublishing.com

For customer service and orders:
Toll-Free 1-888-313-2665

Visit us on the internet at http://www.arcadiapublishing.com

*Thanks to all the members of my family for their love
and support and to the staff at Photo Services and
Special Collections, who supplied me with the pictures
and their invaluable knowledge.*

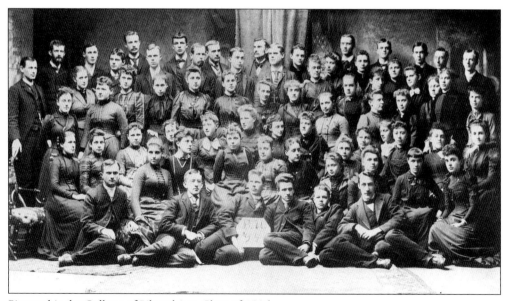

Pictured is the College of Liberal Arts Class of 1894.

CONTENTS

January 23, 2002

From a deck on the roof of Boston University's College of Arts and Sciences, just above the lights of Commonwealth Avenue, visitors to Judson B. Coit Observatory have a view of the evening sky that is rare in the midst of the city. Looking down along the banks of the Charles River, they can survey the university's history as well.

In the east one can just make out Beacon Hill, where, in 1869, three wealthy Methodist merchants committed their fortunes to shoring up a theological seminary that had come south from its beginnings in Vermont. The university's first campus in Boston offered spacious rooms decorated with landscape paintings and busts of Greek gods, but its facilities were still rather humble. The students of Judson Coit, one of the university's first astronomers, had to use pay telescopes on the Boston Common to observe the constellations above.

Boston University's modest origins, however, were augmented by its founders' daring. Dedicated from the first to educating both women and men and to persons of all creeds and colors, the university has set its own extraordinary course.

This collection of photographs charts that course across changing addresses, and succeeding generations, each clothed in the fashions of its time. You will find Judson Coit's portrait among the hundreds in this book, along with pictures of the many campuses that the university has inhabited at one time or another. I hope, however, that you will see a continuity of spirit in the journey from Alexander Graham Bell's seersucker to Isaac Asimov's lab coats, and from the university's beginnings in rural New England to Beacon Hill and, in time, to the splendid campus it enjoys today.

Coit's expertise was in the nineteenth century mathematics of quaternions, an algebra that used sets of equal numbers to chart vectors and even map the stars. Across its history, Boston University has relied on its own unusual algebra to give men and women of every background the fulfillment that education could promise. I hope you enjoy these portraits of a university in constant pursuit of its hopes.

Jon Westling
President

INTRODUCTION

Boston University is an educational institution renowned throughout the country and the world. It has an intriguing history. The school was not founded in Boston nor was it initially a university. Unlike many schools, it did not begin with a liberal arts school but as a Methodist theological school, and it was not built on a large plot of land.

The Methodist Church was founded in England by the Oxford graduate John Wesley. He ministered to the downtrodden and sought to educate the workers affected by the Industrial Revolution. The Methodist movement arrived in America in 1766. Wesley appointed itinerant ministers to travel about the countryside, preaching to scattered congregations. The men tried to study along the way.

At a conference in Boston in 1839, a group of Methodists raised $15,000 to train ministers. Since there was not enough money to buy property in Boston, they took advantage of an invitation from a secondary school in Newbury, Vermont, to join them, and the Newbury Biblical Institute was founded.

By 1846, officials of the institute desired to move it closer to Boston. A two-story building was donated and renovated by a Congregational church in Concord, New Hampshire. The institute and 12 students relocated to become the Methodist General Biblical Institute. Although money was difficult to raise, the school received donations of beds, stoves, and used books. The students traveled many miles every Sunday to preach to scattered congregations.

John Dempster, an outstanding example of an itinerant minister and an important name in the development of Boston University, realized the need for a formal education, although he did not receive one himself. He raised funds for the school at its two upcountry sites as he traveled many miles about the countryside. He was also a professor at both sites.

Finally, in 1867, the school moved again; it became known as the Boston Theological School and moved into rented property on Beacon Hill. The three founders petitioned the Massachusetts General Court in 1869 to incorporate the Trustees of Boston University. By 1871, Boston was eliminated from the name, and the School of Theology became the first department of the university. The university had no restrictions according to race, gender, or religion—except that the theology school was permitted to consider "religious opinions."

Several schools and colleges were founded in the next few years. The School of Law, founded in February 1872, was the second. The school was the first in the nation to require entrance exams and a three-year course of study. One quarter of the students were women. The College of Music, which accepted only graduate students, was established in May 1872. For almost 20 years, the college shared space and professors with the New England Conservatory of Music.

The Boston University School of Medicine assumed the debt of the New England Female College of Medicine and finished the classroom buildings that the Female College had begun to

construct in the South End. By February 1873, the School of Medicine moved in, and the classes were coeducational. The College of Liberal Arts (CLA, now the College of Arts and Sciences) was founded in May 1873 on Beacon Hill. From May 1873 to 1880, the short-lived School of Oratory occupied the same building. Alexander Graham Bell was hired as an instructor. In an attempt to develop a device to transmit multiple telegraph messages on a single wire, he invented the telephone. In 1874, the School of All Sciences (now the Graduate School of Arts and Sciences) was established.

Since there were not as many males as females in CLA, it was decided to offer business courses to attract more men. The College of Business Administration (now the School of Management) was founded in 1913 and moved into a building on Boylston Street in the Back Bay when the enrollment was greater than expected.

Many of the graduates of CLA became teachers. The School of Education was established by 1918. The university acquired the Sargent College of Physical Education as a gift in 1929. The School of Religious Education and Social Service separated from the School of Education in 1920. Some departments became the School of Social Work in 1940, and others merged with the School of Theology.

The School of Public Relations (now the College of Communication) began in 1947. The College of Music was closed for a time, was absorbed by CLA, became an independent college within the university in 1928, and is now a part of the College of Fine Arts. After having been a division of the School of Education, the School of Nursing was established in 1946.

Over the following decade, several of these schools changed their names and others were added. The College of Industrial Technology of 1950 became the College of Engineering in 1963. The School of Graduate Dentistry (now the Goldman School of Dental Medicine) opened in 1963 in the South End. The arts were gathered together as the School of Fine and Applied Arts (now the College of Fine Arts) in 1955. By 1965, Metropolitan College offered courses in the late afternoons, evenings, and on Saturdays. In 1972, the University Professors Program taught interdisciplinary curricula.

By spring 2001, there were 17 schools and colleges at the university, with more than 22,000 full-time, part-time, and nondegree students. They were taught by more than 3,400 full-time and part-time faculty, and the staff was more than half again that large. Boston University has many international students. The number of living alumni exceeds 230,000. There are 17 libraries. The size of the two campuses and the number of buildings, classrooms, and laboratories increase steadily. This book does not even begin to tell the whole story.

One

IN THE BEGINNING
1839–1866

The men who met at a Methodist conference in Boston in 1839 wanted to found a school to train Methodist ministers for the churches that had already been established. The men realized that they did not have enough money to buy property and a building in Boston to establish the school.

The Newbury Seminary had been founded in 1834 in Newbury, Vermont. The first high school in Vermont to provide an education for young men and women from a wide area of the state, it invited the conference to use its church and classroom building. In return, the young men and women of the seminary were allowed to attend some of the theological classes taught by the professors at the Newbury Biblical Institute.

The scholars at the young Newbury Biblical Institute gained practical experience by preaching in the outlying hamlets and villages, on the farms and lumber camps, and wherever a group was gathered. The men found room and board in the homes throughout the village and were able to find jobs to earn enough money to pay for these necessities.

The next home was in Concord, New Hampshire. In 1847, the institute, renamed the Methodist General Biblical Institute, moved into a former church that had been renovated and given to them by the Congregationalists. The men chopped and sold firewood to earn enough money for their upkeep.

Finally, the school moved to Boston (a potential source of special lecturers) in 1867 and became the Boston School of Theology. Thus began the long and arduous journey to establish the present campus on the banks of the Charles River and in Boston's South End.

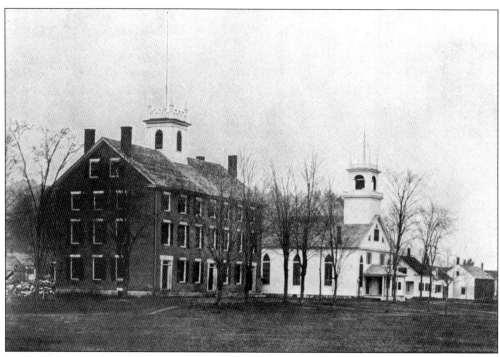

In 1839, the Newbury Seminary and the Newbury Biblical Institute were located in the center of a lovely New England village. The classroom building on the left burned down, to be replaced later by a middle school. The church on the right still exists.

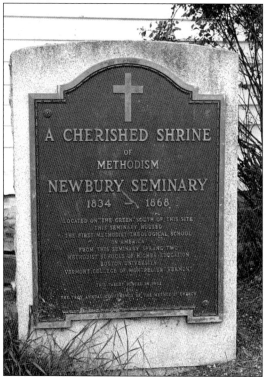

A CHERISHED SHRINE
OF
METHODISM
NEWBURY SEMINARY
1834 — 1868

Methodism grew out of a society formed at Oxford University in 1729 by John and Charles Wesley. Their religious exercises were conducted by the "rule and method," which stressed personal and social morality. They were ridiculed as "Methodists." This tablet was placed by the Troy Annual Conference of the Methodist Church in 1962.

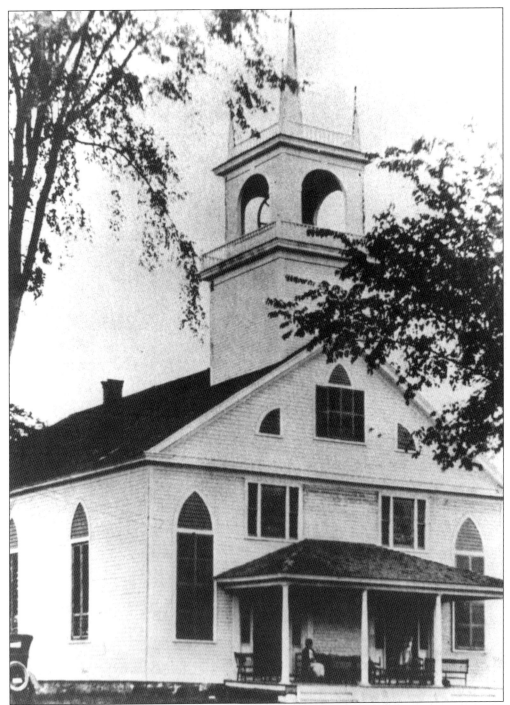

The Methodist church was the heart and soul of the campus of the Newbury Biblical Institute. Constructed of wood, the building had simple Gothic-inspired windows, a handsome steeple with a bell, and a porch where the congregation could gather before the services. Located in the middle of Vermont along the Connecticut River, Newbury was fortunate to have a preacher of its own. This photograph dates from the 1920s.

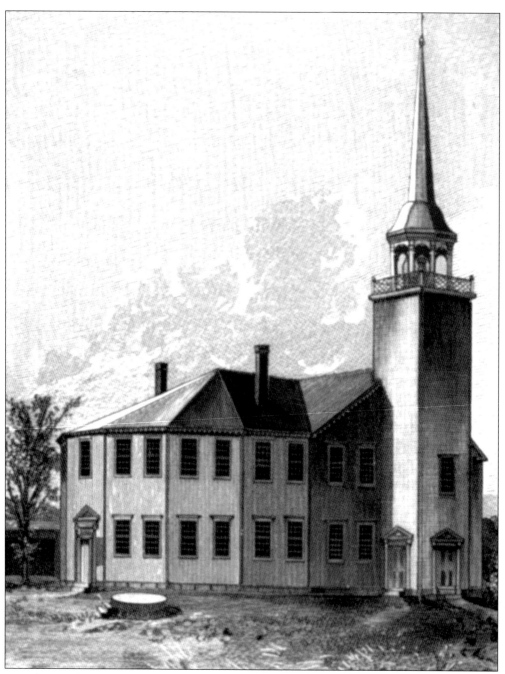

In 1847, in a desire to be closer to Boston, the school was moved to Concord, New Hampshire, and named the Methodist General Biblical Institute. The congregation of the Old North Meeting House moved south to the center of town and gave its multisided building to the institute. The enrollment declined, and the school was moved to Beacon Hill in 1867 and renamed the Boston Theological School. (Courtesy New Hampshire Historical Society.)

Two

A CITY SET ON A HILL
1867–1920

The Methodist General Biblical Institute moved from Concord, New Hampshire, to Boston in 1867. Boston University was chartered in 1869, and the first department was established in 1871. At last, the university had moved to the heart of the city known as the "Athens of America" and the "Hub of the Universe."

After the statehouse was built on Beacon Hill in 1798, the hill behind was lowered by 60 feet, and residences and apartments were constructed on the slopes. The Boston School of Theology moved into a building at 23 Pinckney Street until the Wesleyan Building on Bromfield Street in downtown Boston was finished.

In 1869, Gov. William Claflin signed the petition of the three founders—Lee Claflin, Jacob Sleeper, and Isaac Rich—to incorporate the Trustees of Boston University.

The university experienced amazing growth in the early 1870s. By 1874, it consisted of seven schools and colleges in buildings that were either leased or purchased on Beacon Hill, in downtown Boston, and in the South End. They were the School of Theology, 1871; the School of Law, 1872; the College of Music, 1872; the School of Medicine, 1873; the College of Liberal Arts, 1873; the School of Oratory, 1873; and the School of All Sciences, 1874. Pres. William F. Warren's goal of creating a university on the plan of German universities was realized, and he was able to hire an outstanding faculty.

Some of these schools moved around on Beacon Hill in the 1880s and 1890s, as they needed more space. The School of Religious Education and Social Service was founded in 1920 and, in spring 1921, was moved into a new building on Beacon Hill.

Although most students commuted, a few properties served as dormitories. Several organizations were developed to serve the varied interests of the students outside of the classroom and to give them a sense of community.

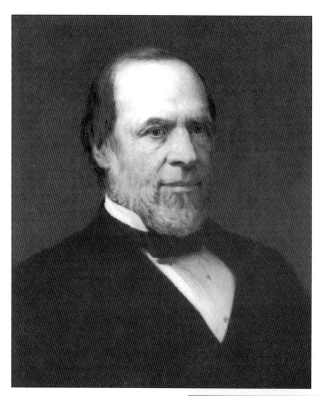

Gov. William Claflin was the son of Lee Claflin, who with Jacob Sleeper and Isaac Rich petitioned the state legislature to charter the Trustees of Boston University in 1869. From the first, except for the School of Theology, no religious requirements could be placed on the students or faculty. Governor Claflin is shown here in a painting done by James Harvey Young in 1900. (Courtesy Commonwealth of Massachusetts Art Commission.)

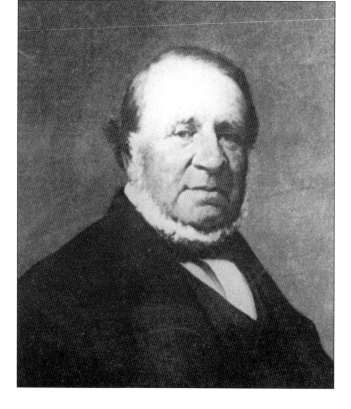

Lee Claflin was born in 1791 into the family of a successful merchant who lost his money after the American Revolution. Still very young when his father died, Claflin served an apprenticeship as a tanner, became a shoemaker, and set himself up in a business, in which he became one of the leaders of the industry. As a founder, he gave generously to the new university.

Jacob Sleeper, also one of the founders of the university, went to work after both of his parents died. He sold clothing to the U.S. Navy at a contracted fixed price and, when there was a recession, he and his partner made a fortune. Later, Sleeper left the business to invest in real estate. He donated a large sum of money to the university.

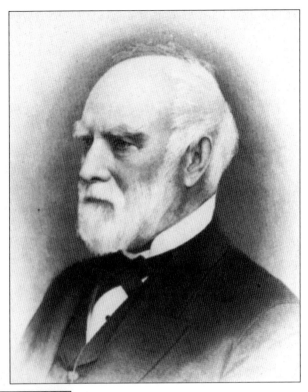

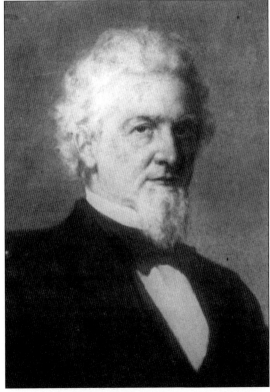

When his father died, Isaac Rich was 14. He continued to sell fish and, by the Civil War, was the largest dealer in New England and owned several fishing and cargo boats. Rich left a $1.5 million estate to Boston University. Unfortunately, the Great Fire of 1872 destroyed one half of his bequest.

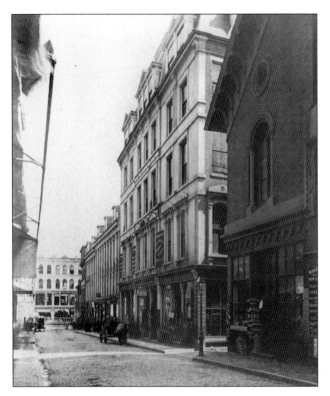

The Boston School of Theology moved into the handsome new five-storied Wesleyan Building at 36 Bromfield Street (center) in 1870. The school moved into the two top floors and became the university's first department, known as the School of Theology. The School of Law, established in 1872, also moved into the Wesleyan Building.

William F. Warren was acting president when the Methodist General Biblical Institute moved to Boston in 1867. He was acting president of the university from its founding in 1869 and became the first president in 1873. At his suggestion, the school was modeled after the universities in Europe. Following the Methodist belief in social equality, the university was open to all regardless of race, gender, class, or creed.

Some of the School of Theology male students boarded on Beacon Hill. One of these buildings was Beebe Hall, on Willow Street. The nine-story building was topped with a mansard roof.

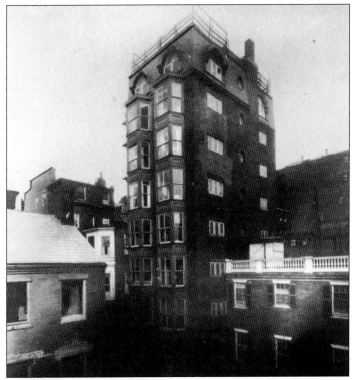

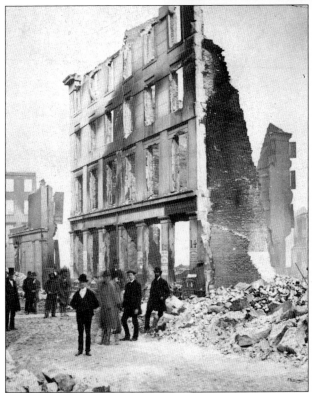

The legacy of the $1.5 million that Isaac Rich left was the largest gift ever bequeathed to a college or university in this country, but the idea of naming the school Rich University was dismissed as a hindrance to future fundraising. The Great Fire of 1872 swept away 40 acres of the commercial district of downtown Boston and the waterfront, including half of Rich's bequest.

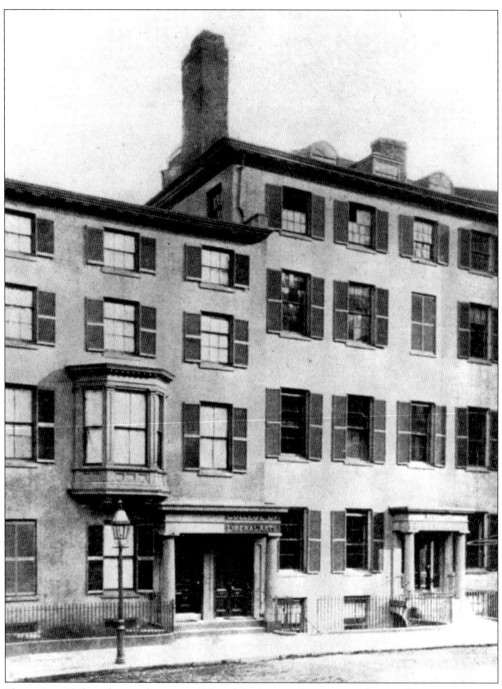

The university bought two houses at 18 and 20 Beacon Street near the statehouse on Beacon Hill. The College of Liberal Arts, the School of All Sciences, and the School of Oratory were located here. A room at 18 Beacon Street was used for daily chapel, meetings, and recreation. Steep and narrow staircases led to the classrooms and offices.

Prof. Augustus Howe Buck was one of the first six members of the faculty at the College of Liberal Arts. Students were expected to know Greek and Latin when they arrived. Buck taught Greek and realized that his first-year students might find the texts difficult to read on their own, but the sophomores were expected to come to class well prepared.

Members of the School of Theology gather in front of the Robinson Chapel in the 1870s. Although women could be admitted at that time, there are none in the picture.

Anna Howard Shaw, pictured here, was the second woman to graduate from the School of Theology (1878). She graduated from the medical school in 1885. The first woman to graduate from the School of Theology had been Anna Oliver (1876). When she enrolled, Oliver dropped her family name of Snowden and took her aunt's name of Oliver because her brother was upset over her determination to study theology. Neither Shaw nor Oliver found acceptance as a Methodist minister.

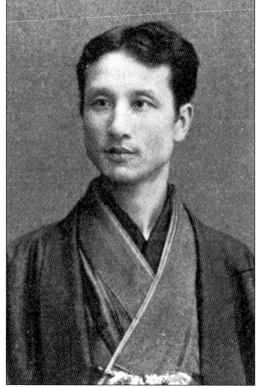

Takeo Kikuchi was the first Japanese person to graduate from the School of Law (1877). He was the founder and first president of Chuo University, a private university established in 1885 in Japan. It promoted teaching in the spirit of democracy and the principles of English law.

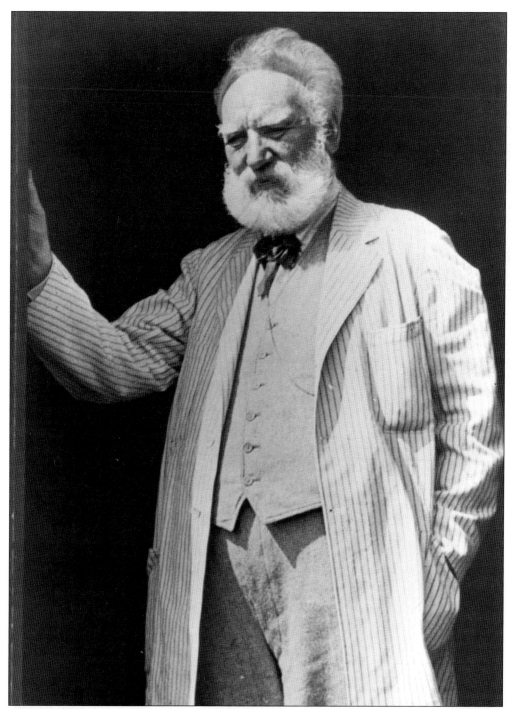

During the 1870s, Alexander Graham Bell was the professor of vocal physiology and elocution at the short-lived School of Oratory, where his courses included the Culture of the Speaking Voice. While working on a device to transmit up to six telegraph messages over a single a wire, he developed the telephone. In 1876, his assistant, in another room, heard the first transmitted sentence, "Mr. Watson, come here; I want to see you."

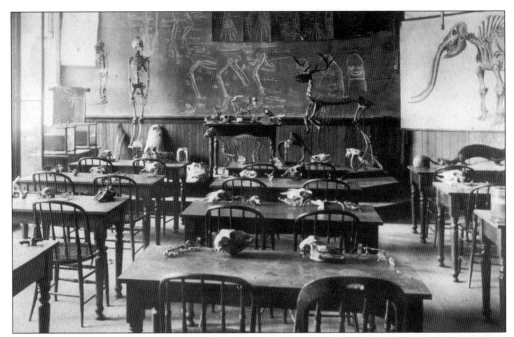

College of Liberal Arts students who were interested in historical geology had to make their way from Beacon Hill to the Natural History Society in the Back Bay. Until 1904, lab science classes at the College of Liberal Arts were taken at the society or at the Massachusetts Institute of Technology.

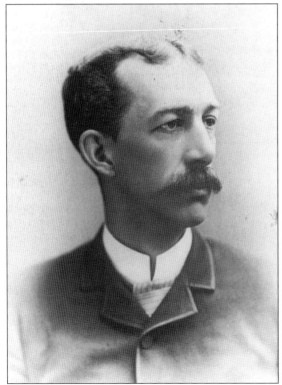

Thomas Bond Lindsay became assistant professor of Latin and Sanskrit at the College of Liberal Arts in 1878 and a full professor by 1883. Latin was required in most liberal arts schools, but the teaching of Sanskrit was unusual. His classes in both languages were well attended.

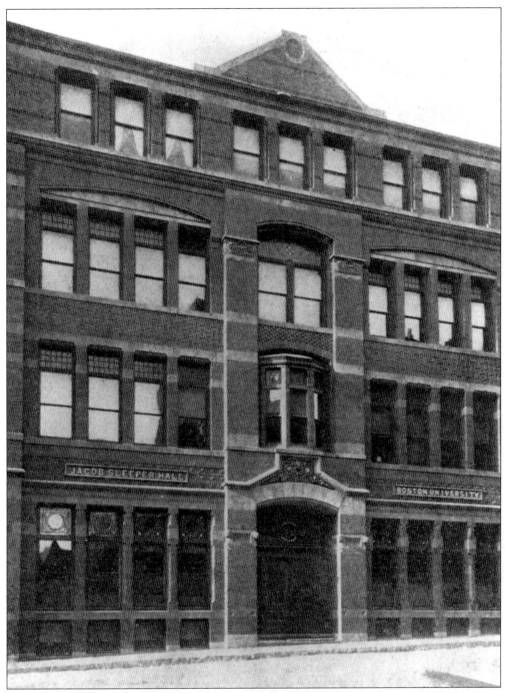

In 1882, the College of Liberal Arts and the Graduate School of Arts and Sciences moved from Beacon Street to a former Baptist church at 12 Somerset Street, behind the statehouse. The spire was removed and a Renaissance-style facade was added. The sanctuary was divided into three stories. In 1895, the School of Law moved out of the townhouses on either side of the structure, and the three buildings were connected through their basements.

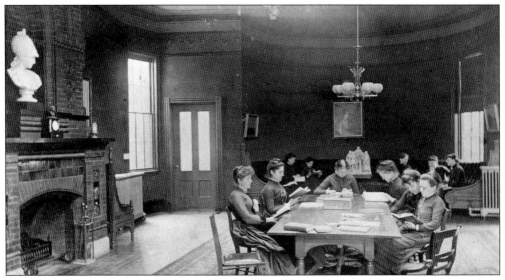

A spacious room on the second floor of 12 Somerset Street was set aside for this study, fondly known as the Parthenon. In this *c.* 1886 photograph, several ladies are seated at a table and on comfortable benches. A bust of Minerva, the Roman goddess of wisdom, is above the fireplace.

In 1881, Lelia Josephine Robinson was the first woman to graduate from the School of Law. She was also the first woman to be admitted to the Massachusetts Bar when, in 1882, the state legislature passed a bill permitting women to practice under the same conditions as men. Robinson became an advocate of the role of women in the law.

For several years, there was no gymnasium for the men at 12 Somerset Street, perhaps prompting this drawing in the *Hub* yearbook. The gentleman looks more like a growing figure in *Alice in Wonderland* than a man with enough room to lift weights.

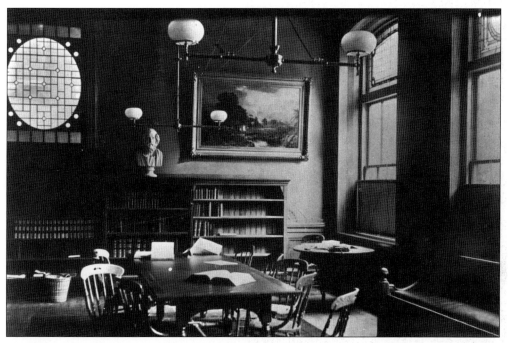

By 1882, a study for men was located in a long narrow room on the first floor, with windows opening to the noisy street outside. A bust of Homer sat on a bookshelf next to a divan covered in Turkish brocade. A bulletin board announced class meetings, debates, and other college events.

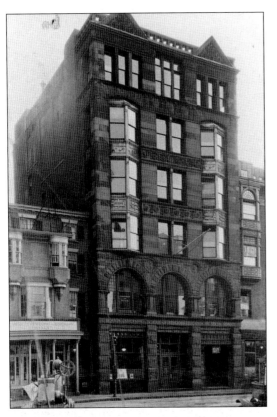

In 1884, after the College of Liberal Arts had moved from the former townhouses at 18 and 20 Beacon Street, No. 20 was demolished and the portico of No. 18 was modified. The building was designed for the School of Religious Education and Social Service, which was reorganized in 1940 as the School of Social Work, with some departments moving to the School of Theology. Only the entwined *BU* on the fourth floor reminds us that the building was once owned by the university.

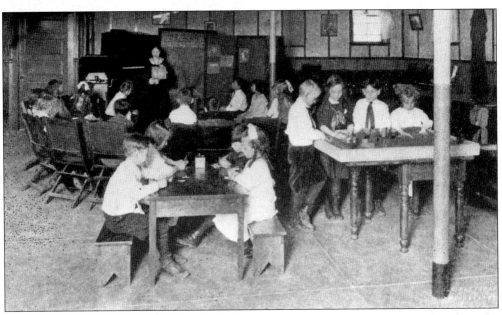

Third-grade children are shown at a weekday religious school class taught by a student from the School of Religious Education and Social Service (SRE). Part of the SRE education was to go into the community to practice teaching under trained supervisors.

In 1882, Judson B. Coit came to the College of Liberal Arts to teach mathematics and astronomy. His courses included analytics, calculus, and quaternions (a mathematical system used in celestial navigation). His first astronomy students used the pay telescopes on the Boston Common. Later, alumnus James Woodson contributed funds for the first telescope, and L.W. Tycott donated the second. Wilbert Gilmour supported the maintenance of the observatory in 1906.

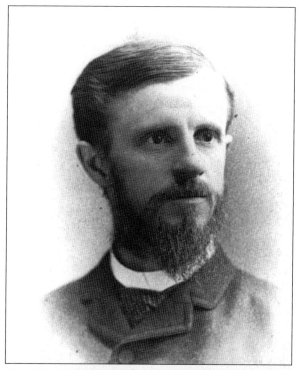

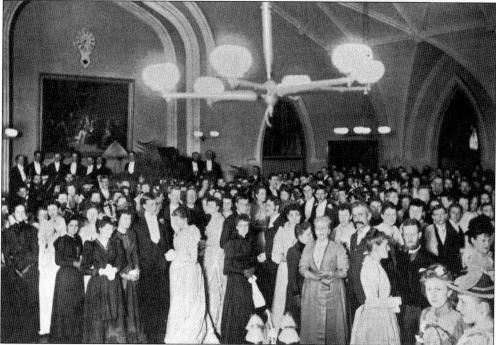

The Gamma Delta Ladies Literary Society was a nonsecret society that organized a very popular event called the Klatsch Collegium for the enjoyment of the whole school. A dinner dance was held every February in the chapel of 12 Somerset Street for more than 1,200 guests. The professors gauged their popularity by the number of invitations they received from the students.

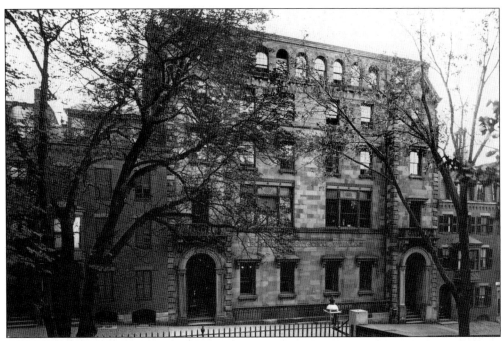

In 1884, the School of Theology moved to new quarters in the former twin mansions of the Thayer brothers at 70–72 Mount Vernon Street. After renovating the buildings, there was sufficient space for lectures, reading and library rooms, offices for the faculty, a residence for the dean, and lodging for 100 students and 7 professors. The building was considered the finest at any theological school in the country.

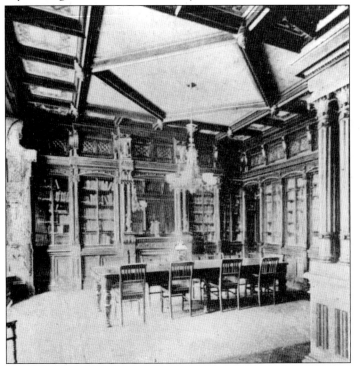

The School of Theology Library was located at 70–72 Mount Vernon Street. The chandelier in the high ceiling of the library illuminated the room at night, and the large windows that looked out onto Louisburg Square provided ample light on a sunny day.

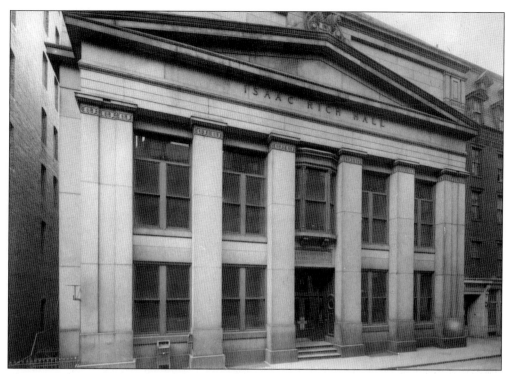

After several moves, the School of Law moved to 11 Ashburton Place (renamed Isaac Rich Hall) in 1886. The former Mount Vernon Church was renovated to contain a lecture hall, a library, classrooms, and offices. During their limited free time, the students visited the courts and the statehouse. Founded in 1872, the School of Law admitted women and required a three-year course of study.

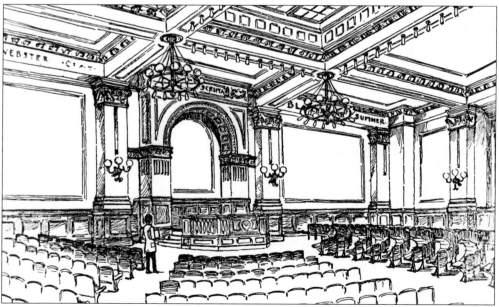

The lecture hall at the School of Law was located on an upper floor. Names of famous lawyers graced the top of the auditorium: Webster, Clay, Blackstone, and Sumner.

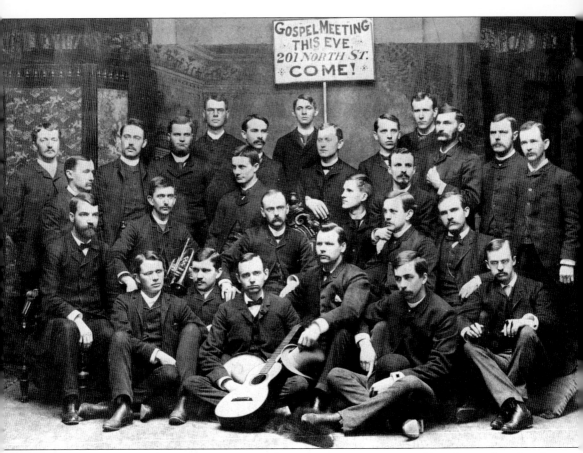

The School of Theology had a variety of missionary activities. In 1887, the student band entertained and summoned people to a meeting in the North End. The population was composed mainly of Irish, Italian, and eastern European immigrants whose religion was Roman Catholic or Jewish, not Protestant.

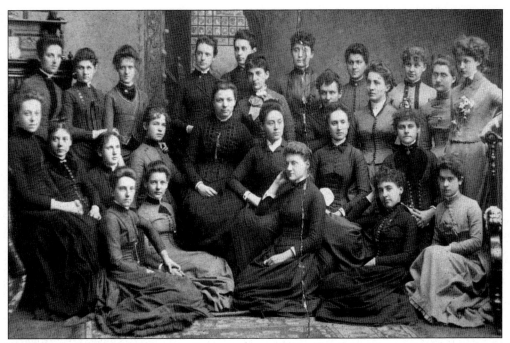

The Gamma Phi Beta sorority, Delta chapter, was established in 1887. Other sororities on Beacon Hill were Kappa Kappa Gamma, 1882; Alpha Phi, 1883; and Delta Delta Delta, 1888. Most of the women commuted, and social groups gave them a sense of belonging.

James Geddes Jr. joined the faculty at the College of Liberal Arts in 1887 to teach the Romance languages and phonetics. He taught for nearly 50 years. The James Geddes Jr. Modern Language Study remained part of the College of Liberal Arts when it moved from 688 Boylston Street to the Charles River Campus in 1947.

31

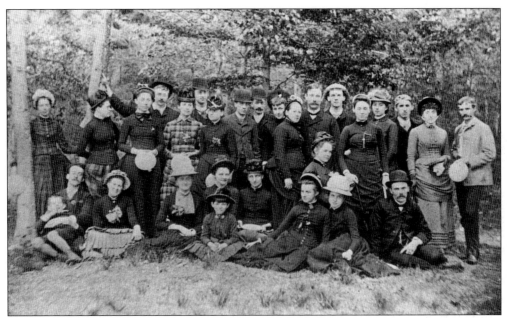

Seniors from the College of Liberal Arts enjoy a picnic in the country in May 1887. Note the number of women in the group. In 1873, the announcement of the new college had stated that "ladies will be admitted to all of the privileges of the College on the same conditions as the gentlemen."

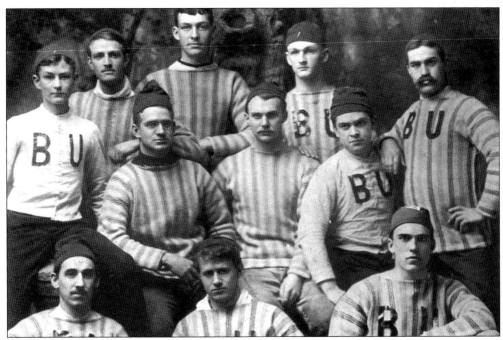

The 1886 football squad wore no protective gear. In the lower left is William E. Chenery (Class of 1887). In 1947, the top floor of the new College of Liberal Arts building at 725 Commonwealth Avenue was occupied by the Chenery Library, named in honor of Dr. and Mrs. Chenery for their many generous gifts.

Without any large fields, barns, or silos in evidence, how did the university have an agricultural college from 1876 to 1912? When students graduated from the Massachusetts Agricultural College at Amherst, they could receive a bachelor of science degree from Boston University for a fee of $10. Franklin W. Davis (Class of 1889), the tallest student in the back row, took advantage of this offer. He became a Boston newspaperman. (Courtesy Special Collections and Archives, W.E.B. Du Bois Library, University of Massachusetts Amherst.)

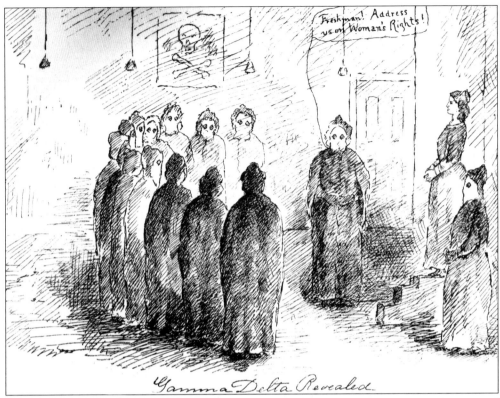

The Gamma Delta Ladies Literary Society, depicted here at an initiation ceremony, was organized in 1877. Among its guest speakers were Julia Ward Howe, Branson Alccott, and Lucy Stone.

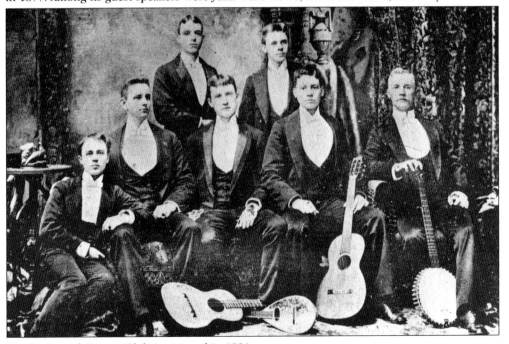

The Banjo and Guitars Club is pictured in 1891.

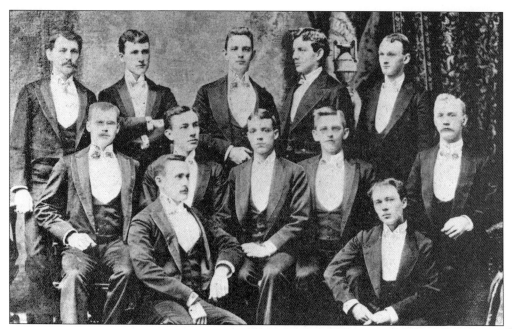

In 1891, the members of the Boston University Glee Club were C.T. Snow and G.W. Buck, first tenors; J.F. Harlow and A.I. Warren, second tenors; W.S. Hawkins and W.A. Young, first bass; W.C. Fessenden, G.A. Wilson, and G.F. Kenney, second bass; Fred Winslow Adams, reader and impersonator; G.F. Kenney, musical director; and J.W. Spencer, business manager.

In 1894, the freshmen of the College of Liberal Arts sponsored an all-college event featuring songs, games, and dances. The event, known as the Philomathean, was held in Jacob Sleeper Hall, at 12 Somerset Street. This was the first of three halls and a dormitory by that name. Jacob Sleeper was one of the three founders of the university.

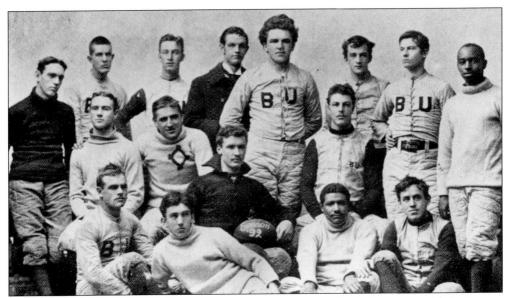

E. Ray Speare (holding the ball) organized and captained a football team in 1892. He was university treasurer for many years. Pictured from left to right are the following: (front row) Jewel Flower, left end; J.W. Schenk, right end; H.C. Sanborn, left tackle; and W.F. Rogers, right tackle; (middle row) W.D. Whitney, left guard; H.L. Phillips, right guard; E. Ray Speare, fullback; and Frank J. Mahoney, center; (back row) R.H. Sherman and J.D.R. Woodworth, halfbacks; W.H. Jackson; and five substitutes.

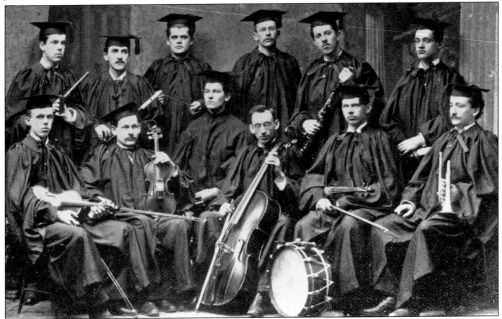

The Orchestral Club is pictured in 1894. The members are, from left to right, as follows: (front row) F.R. Miller and F.H. Hodge, first violin; unidentified; W.E. Butler, cello; H.H. Ryder, second violin; and H.M. Webster, cornet; (back row) E.M. Bosworth and H.W. Barlett, flute; F.S. Overhiser, director; unidentified; A.L. Pitcher, clarinet; and unidentified. Absent from this photograph are club members Jewell Flower and C.W. Pierce.

THE UNIVERSITY BEACON.

VOL. XX. BOSTON UNIVERSITY, THURSDAY, OCT. 11, 1894. No. 1.

THE UNIVERSITY BEACON is published semi-monthly during the College Year by the University Beacon Association of the College of Liberal Arts of Boston University. Terms, $1.50 if paid before Dec. 1st, otherwise $2.00. Single copies, 15c.

All exchanges and communications should be addressed to THE UNIVERSITY BEACON, 12 Somerset Street, Boston, Mass.

Articles for publication must be sent in by the first and fifteenth of the month, respectively.

Any subscriber who fails to receive THE BEACON should notify the Business managers.

THE BEACON is forwarded to all subscribers until an explicit order is received for its discontinuance, and until all arrears are paid, as required by law.

Entered at Post-office as second-class matter.

THE BEACON IS FOR SALE AT THE COLLEGE BOOKSTORE.

Sanctum.

VOLUME XX.

THE BEACON begins its twentieth volume under promising circumstances, pursuing an energetic policy, with an increased number of pages and departments. The hope that this twentieth volume may show a marked advance in the success of the paper seems fairly justified.

NINETY-EIGHT!

Now that welcomes and praises have bee ringing in your Freshman ears for thre weeks or more, the BEACON feels that would be quite superfluous to extend it assurance of welcome, and for the sake variety, would suggest for your consideratio this little word of wisdom: " Beware of be ginnings." . . . qui

. . . Freshson . . . will . . . etermin . . . urse, an . . . ward colleg . . . uture position . . . eneral sense . . . to the mat . . . Th . . . ently . . . offe . . . scrip . . . enu . . . par . . . awake . . .

. . . fo . . . in . . . vhil . . . pularity

. . . noble . . . the two . . . of the Coll . . .

The Debat . . . an Society and Philolog . . . t for all. S indispensable an . . . a college educa- tion as the Debating Club needs no word o commendation from us; the Philomathean Society will attract you involuntarily, while th

The *Boston University Beacon* newspaper was first published jointly by the Schools of Law, Medicine, and Theology and the College of Liberal Arts in 1876. When this combination proved cumbersome, the name was changed by the College of Liberal Arts to the *Beacon* in 1889 and then to the *University Beacon*. In 1885, the newspaper published a large issue that became the first *Hub* yearbook.

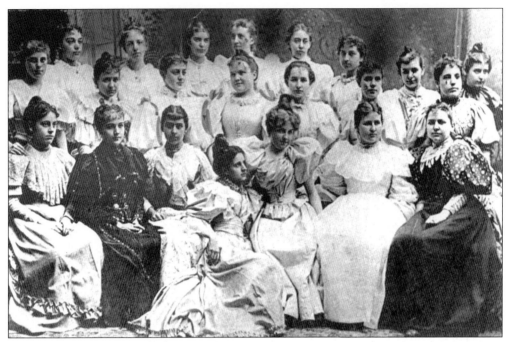

The Gamma Phi Beta sorority was founded at Syracuse University in 1874. The Delta chapter at Boston University was established in 1887.

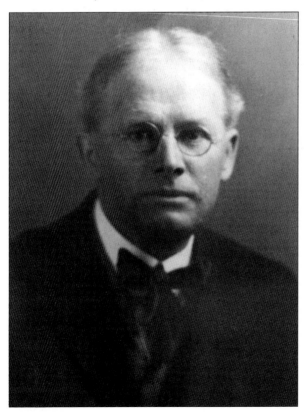

Dallas Lore Sharp earned a graduate degree at the School of Theology in 1899 while he served as assistant librarian at the College of Liberal Arts. In the fall of that year, he began to teach English composition on a part-time basis and, by 1901, was teaching full time. Each composition was corrected in sometimes excruciating detail to help his students develop a clear and concise style of writing. He retired in 1926.

The Men's Club is shown here in 1895, when it was organized because the ratio of males to females at the College of Liberal Arts had decreased. A warm welcome was extended to all of the young men to promote a genuine fellow feeling and a loyal school spirit. Monthly meetings were held in the home of a member, and there was a yearly party called the Ausflug.

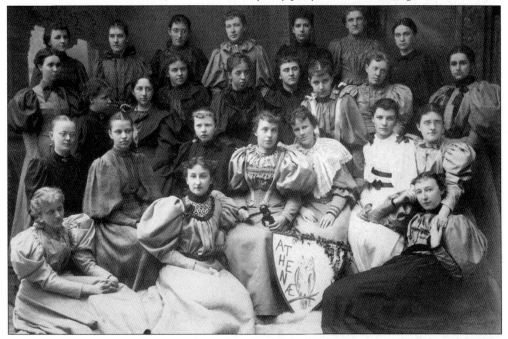

One of the many social clubs at the university was the Athenae Society, celebrating the Greek goddess of wisdom and the arts. The club is shown here in 1895.

The Men's Club made Boston University more attractive to male students with activities such as this—a game of shove, shove.

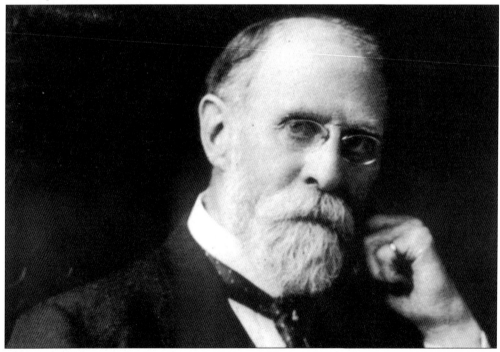

William E. Huntington received his doctor of philosophy degree from the university in 1878 and became the professor of ethics and history at the College of Liberal Arts (CLA). When CLA moved to 12 Somerset Street in 1882, Huntington became the dean and continued to teach part time. He served as the second president from 1904 to 1911. Acting dean of the Graduate School of Arts and Sciences since 1910, he then became dean. Like Pres. William F. Warren, Huntington was a Methodist minister.

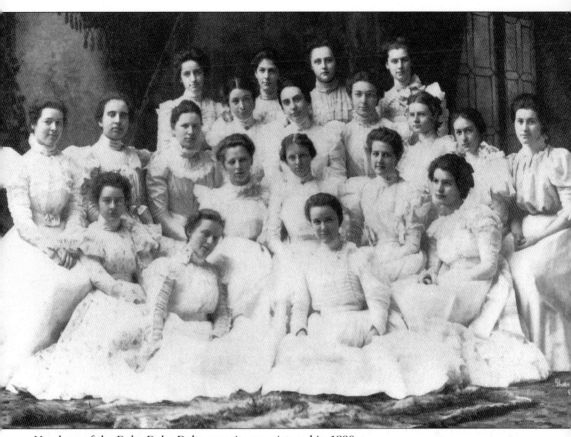

Members of the Delta Delta Delta sorority are pictured in 1890.

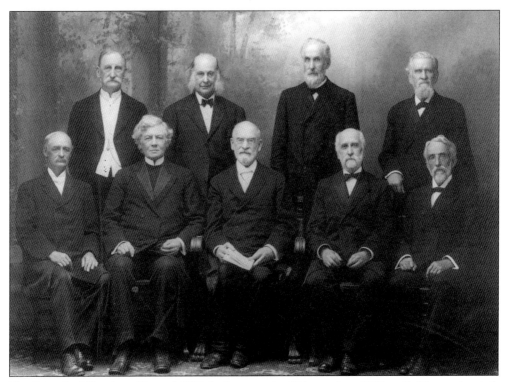

The School of Theology Class of 1871 is shown at its 40th reunion. William F. Warren (seated, center) became acting president of the university in 1869 and president in 1873.

In 1916, the Gothic-style Robinson Chapel was added to the School of Theology at 27 Chestnut Street on Beacon Hill. The classrooms and offices had already moved into 70–72 Mount Vernon Street. Both buildings have since been converted to condominiums.

Three

HEALING AND LEARNING
IN THE SOUTH END
1872–2001

By the 1870s, Boston's elite were moving away from the once elegant South End, and real estate became affordable. Three Boston University schools and colleges were located there.

The College of Music shared the facilities and faculty of the New England Conservatory of Music. First located in downtown Boston, they both moved to the former St. James Hotel, an apartment-style structure on the corner of Tremont Street and East Newton Street. The College of Music accepted only graduate students. After the two schools separated, the Boston University College of Music moved to the Back Bay. It was out of existence from 1891 to 1928, was absorbed by the College of Liberal Arts, and eventually became part of the School of Fine and Applied Arts.

The School of Medicine, incorporating the New England Female Medical College, opened in its classroom building and used the Massachusetts Homeopathic Hospital for practical training.

The university used a large building on St. Botolph Street as a gymnasium. Commencement exercises were held in the Boston Arena, built in the front part of the Boston University gymnasium.

The College of Secretarial Sciences began in 1919 and, in 1924, was renamed the College of Practical Arts and Letters (PAL). Several sororities were founded at PAL as a way for the students to meet one another. The dormitory was called Murlin Hall for the third president, Lemuel H. Murlin. Every spring, a May Day celebration was held in Brookline with an honor court, women carrying an ivy chain, and dancers representing different countries.

In 1996, University Hospital merged with the Boston City Hospital to become the university's Boston Medical Center.

The New England Female Medical College (left) was founded in 1848 at 80 East Concord Street. The Massachusetts Homeopathic Hospital (right) was founded in 1855. The hospital assumed the debt of the Female Medical College, and the two were merged in 1873 to form the Boston University School of Medicine. This photograph dates from *c.* 1880.

An understanding of pathology was an important part of a medical student's education. This view shows x-ray apparatus being used in the Pathology Laboratory.

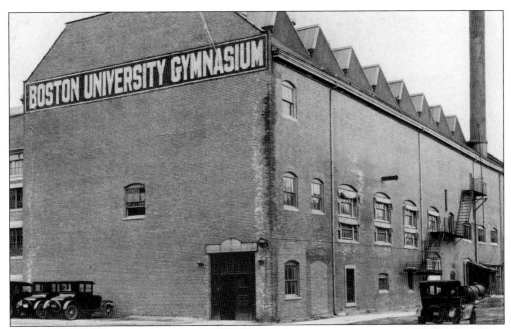

The St. Botolph Street gymnasium was located in what looked like an old warehouse. A large sign across the front of the building announced the function of part of the building. The men walked from Copley Square to use the facilities rather than the cramped space in the Jacob Sleeper Hall Gymnasium. The rear two thirds of the structure were later incorporated into the Boston Arena, which was dedicated on April 16, 1910.

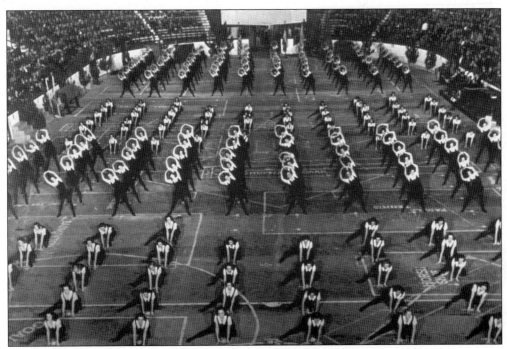

At the Boston Arena, Sargent College physical education majors give a demonstration of the types of physical exercises they would use later when they went out to teach.

In 1924, the College of Practical Arts and Letters was located at 27 Garrison Street at the corner of St. Botolph Street. The classroom building on the left was purchased from the Massachusetts College of Pharmacy. Many of the graduates went on to teach high school business classes.

In 1921, the YWCA club would meet at the College of Practical Arts and Letters at 2 p.m. on Fridays to hold a Bible study. The club had been organized at Boston University on November 15, 1895. A group of young women had decided that they were attending classes and completing their assignments, but they were not tending to the needs of the less fortunate.

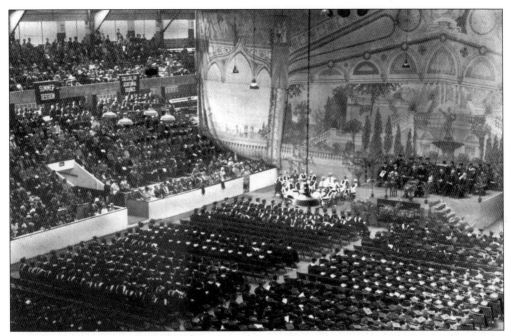

As the university grew over the years, it used various large venues to hold commencement exercises. One of these was the Boston Arena, at 238 St. Botolph Street, where this graduation was held in 1927. The building was also used for ice-hockey games and other events.

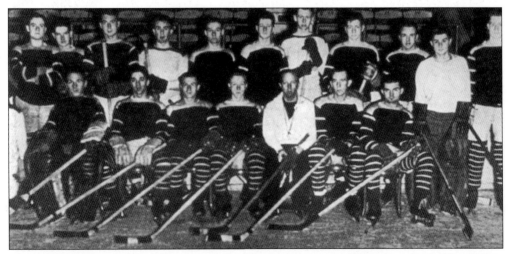

The 1938 hockey team played home games in the Boston Arena, where they also held practices. Many of the team members had played on their local high school teams.

The College of Practical Arts and Letters held a May Day festival in 1945 on the lawn of the Larz Anderson estate in Brookline, with an honor court and its queen. There were also performances of Indian, Siamese, and Native American dances. Morris Dancers wove long ribbons in an intricate pattern around the maypole.

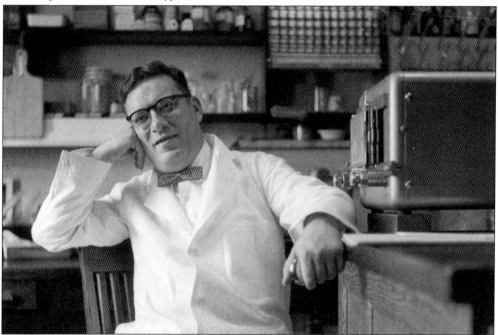

Isaac Asimov began his career at the School of Medicine as an instructor in the Department of Biochemistry in 1949 and later became a full professor. He coauthored a textbook of biochemistry with two others. Asimov is best known for his prolific writing of science fiction, such as the *Foundation* series. His archives are in the university's Special Collections.

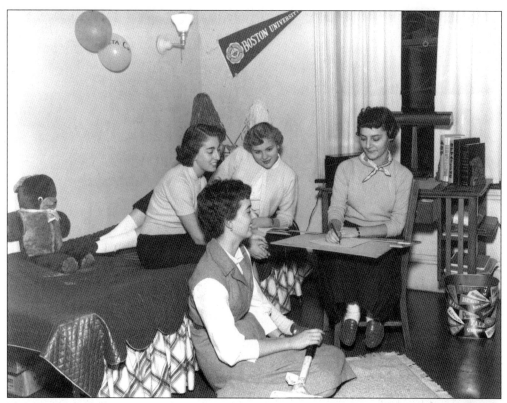

The Murlin Hall dormitory was next to the College of Practical Arts and Letters classroom building on Garrison Street in the South End. Sigma Delta Chi was a local sorority at the college.

In 1954, members of the staff of the Massachusetts Memorial Hospitals (formerly the Massachusetts Homeopathic Hospital) were part of a committee to make plans for a momentous event. The fanciful figure of the elusive mammal enlivened the celebration of Groundhog Day at the teaching hospital of the university's School of Medicine in the South End of Boston.

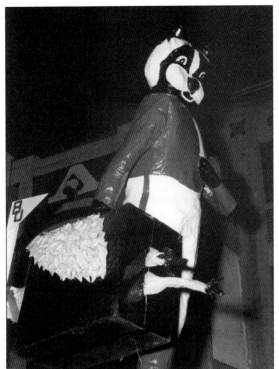

On November 14, 1958, a float pronouncing, "Have Eagles—Will Travel" made its way down St. Botolph Street to the Boston Arena before a hockey game between Boston University and Boston College, the great rival in town. This Boston terrier carries a suitcase with the heads of two scrawny Boston College Eagles sticking out.

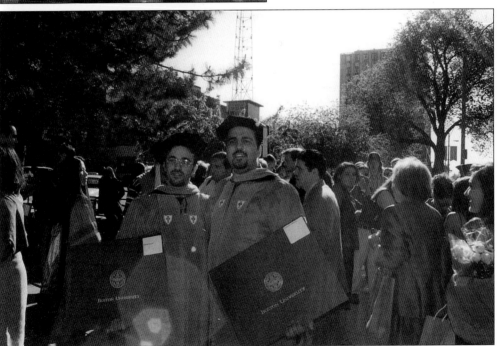

The School of Graduate Dentistry (now the Goldman School of Dental Medicine) was founded in 1963 as the first graduate school of dentistry in the country. The students came from many areas to receive advanced training. Bashar Zyand (left) and Sam Vihoury (right), from Syria, graduated in May 2001.

Four

Learning in the Back Bay
1907–1967

The section of the city known as the Back Bay did not exist when Boston University was founded in 1839 in Newbury, Vermont. A marsh stretched along the Charles River from the Boston Common toward the west to the present Kenmore Square in Boston. The Public Gardens were completed in 1837. The filling of the Back Bay through much of the 19th century slowly extended the solid land, and the city expanded.

Several buildings had been constructed around Copley Square. The most notable were Trinity Church Episcopal, the Old South Church Congregational, the Museum of Fine Arts, and the Boston Public Library.

The Harvard Medical School was to the west of the Boston Public Library, at 688 Boylston Street, at the corner of Exeter Street. The second president of the university, William E. Huntington, suggested that the Trustees of Boston University buy the building. They did, and the College of Liberal Arts and the Graduate School of Arts and Sciences had moved there from Beacon Hill by 1907.

More space was added when Jacob Sleeper Hall was constructed between 688 Boylston Street and the Boston Public Library. The 1908 structure contained an auditorium, gymnasium, swimming pool, and other spaces. The schools continued to grow, and new colleges were established in the Back Bay in buildings that were either bought or leased.

The College of Business Administration, developed in 1913 out of a need to offer courses that would appeal to men, was housed in the College of Liberal Arts building at 688 Boylston Street. The College of Business Administration grew so rapidly that a building at 525 Boylston Street was leased from the Massachusetts Institute of Technology in 1916.

Faculty, staff, and students went off to fight in World War I. The Great Depression made inroads in the salaries of the faculty, but not in their loyalty. As the nation recovered, so did the university. Colleges left the Back Bay, and others were established and moved into their buildings.

In 1939, the College of Business Administration moved to the first new building on the Charles River Campus. After World War II, construction continued, with the College of Liberal Arts moving there in 1947. Other schools followed. In 1967, the Boston Public Library bought 688 Boylston Street (then occupied by the College of Basic Studies) for an addition, and the College of Basic Studies became the last school to move to the central campus.

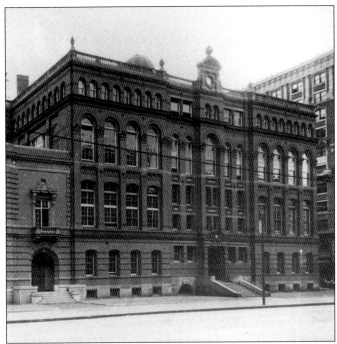

In 1906, at the suggestion of Pres. William E. Huntington, the Trustees of Boston University bought the building at 688 Boylston Street from the Harvard Medical School. The structure on the right was renovated by 1907, and the College of Liberal Arts moved classes, labs, and offices here from Beacon Hill. In 1967, this building (housing the College of Basic Studies) and Jacob Sleeper Hall (containing the auditorium and gymnasium) were demolished for the new wing of the Boston Public Library.

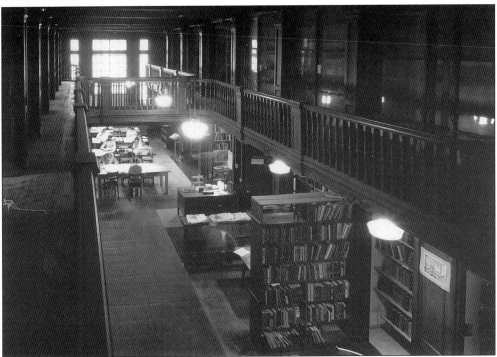

A handsome library was provided for the College of Liberal Arts at 688 Boylston Street. Although several professors had given their collections of books, the holdings lacked certain subjects. Fortunately, the students could use the Boston Public Library next door. The College of Liberal Arts library contained the bookcases of Isaac Rich, a founder of the university, and the desk of the first president, William F. Warren.

Jacob Sleeper Hall was constructed on the vacant lot next to 688 Boylston Street to meet the growing needs of the students and was dedicated on March 5, 1909. The 700-seat assembly hall and the women's study were on the first floor. The Rhoads Gymnasium and swimming pool were in the basement. Despite these improvements, the students continued to use other gymnasiums in the area for their programs and practices.

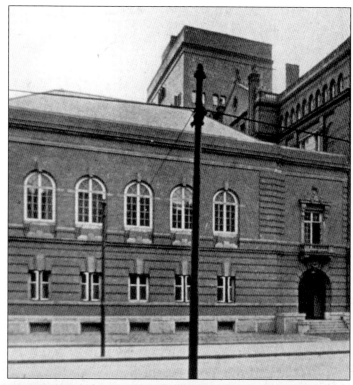

Arthur W. Weysee, professor of biology and director of gymnastics for men, remarked that the American university should take an interest in the physical well-being of its students as well as in the development of their brains. The cost of the Rhoads Gymnasium was met in part by a gift left by Lyman F. Rhoads, a leather merchant of Boston.

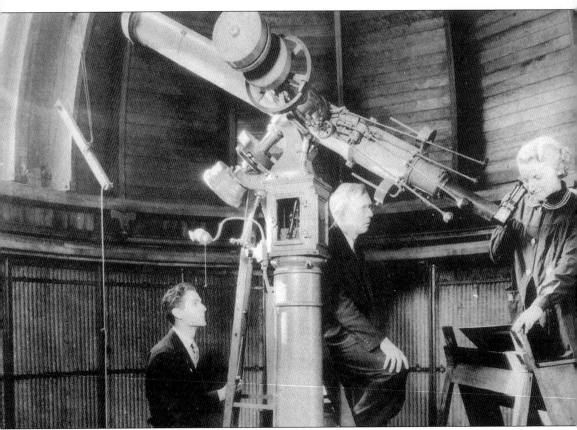

After the College of Liberal Arts moved into the building at 688 Boylston Street, the roof was reinforced to bear the weight of the two telescopes and the observatory that were brought there from Beacon Hill in 1910 for the astronomy courses. The observatory was named for the first professor of astronomy, Judson B. Coit.

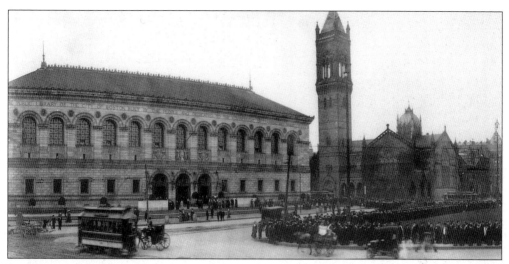

Students and faculty members march toward Trinity Church in Copley Square for the inauguration of Pres. Lemuel H. Murlin in 1911. The Boston Public Library is on the left, and the Old South Church is on the right. Trolley car lines brought commuters to the university's schools in the Back Bay.

Pres. Lemuel H. Murlin came from leading a small college in the Midwest and was eager to learn about the university he described as being "in the heart of the city, in the service of the city." During his tenure, from 1911 to 1925, the property along the Charles River was purchased, but his dream campus was not built in his lifetime.

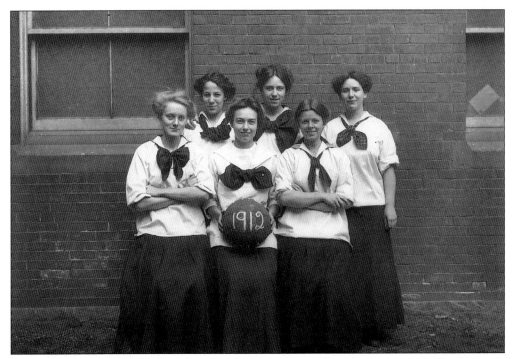

The 1912 girls' basketball team played in the gymnasium of Jacob Sleeper Hall. The forwards were Marion Benton (captain), Dorothea Melden, and Alvidia Chase, and the guards were Grace Burt, Ada Dow, and Marjorie Faunce. In those days, the young women only played on one half of the court with three on a side. They received a penalty if they stepped over the centerline.

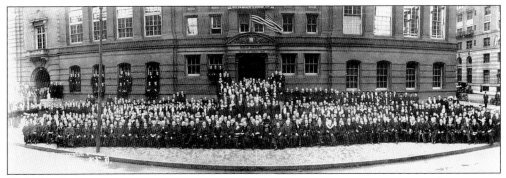

A large group assembles on the stairs, sidewalk, and window sills of the building at 688 Boylston Street to honor the inauguration of Lemuel Murlin as the third president of the university.

Beginning in 1904, the College of Liberal Arts offered chemistry at 12 Somerset Street on Beacon Hill rather than continuing to send students to the Massachusetts Institute of Technology and elsewhere for their classes. In 1910, Helen M. Stevens (College of Liberal Arts, 1908) became the assistant instructor of chemistry (and later the associate instructor). Lyman C. Newell was the first professor of chemistry. Stevens taught in the department for 45 years.

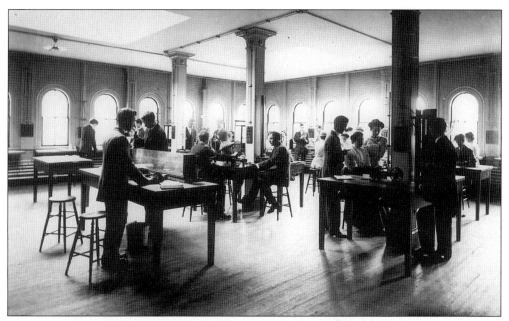

The physics laboratory was situated on the top floor of 688 Boylston Street. The first professor of physics at the College of Liberal Arts was Norton A. Kent. There was ample room and light for the men and women to complete their laboratory assignments.

William Marshall Warren, son of the first president, was dean of the College of Liberal Arts (CLA) from 1904 to 1937 and assistant professor of philosophy. He graduated from CLA in 1887 and also received his doctor of philosophy degree from the university. All freshmen were required to take the dean's course on collegiate life, which featured questions about the campus and downtown Boston.

Katherine E. Hilliker graduated from the university in 1913 and served as registrar and assistant to the dean of CLA, William Marshall Warren. She was the editor of *The College Item,* sent to all of the CLA men and women in the armed services. She was secretary of the fund to build the CLA building on the Charles River Campus. Hilliker retired in 1959 after 45 years of dedicated service.

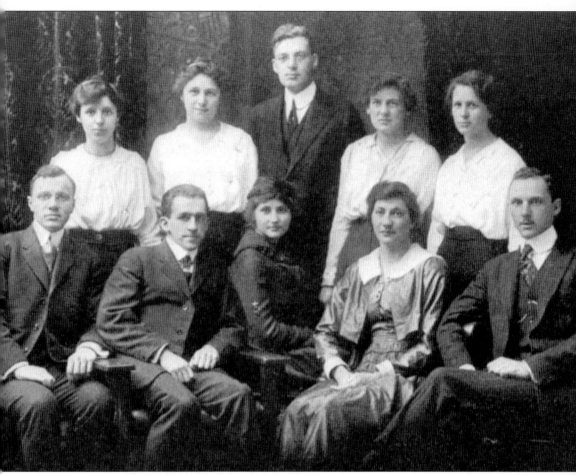

The first-semester officers of the Class of 1917 included Margaret Shea, president; John L. Taylor, vice president; Marguerite Elliott, recording secretary; Alfred E. Longueil, corresponding secretary; Moses R. Lovell, treasurer; and Grace Leonard, assistant treasurer. The second-semester officers were Harland B. Newton, president; Ruth Danforth, vice president; Alfred E. Longueil, recording secretary; Harriet Pettingell, corresponding secretary; Grace Smith, treasurer; and Allen G. McKinnon, assistant treasurer.

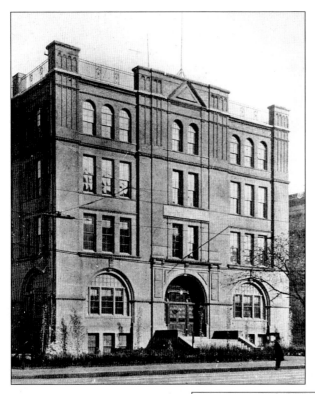

The ratio of men to women attending the College of Liberal Arts had dropped to one in three by 1913. The business courses offered in the evening were so successful in attracting men that the College of Business Administration was founded that same year. In 1916, the College of Business Administration moved to the Walker Building at 525 Boylston Street, which was leased from the Massachusetts Institute of Technology. The building was known as "Ye Olde Mille of Knowledge, Open day and night."

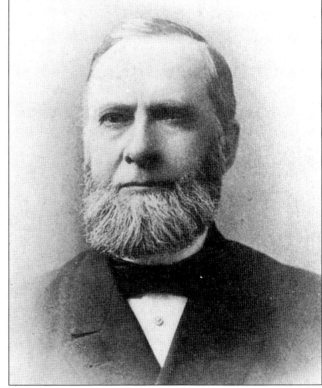

Edward Howard Dunn was a trustee from 1878 to 1906 and named an associate founder in 1907. His large bequest was used by the College of Liberal Arts to help pay for the building at 688 Boylston Street in the Back Bay.

Roswell Raymond Robinson was a trustee from 1902 to 1923. The Robinson Chapel, at 27 Chestnut Street on Beacon Hill, was built behind the twin mansions that the School of Theology had bought at 70–72 Mount Vernon Street. The chapel was named in his honor for the many generous gifts that he had given to the School of Theology. Robinson was named an associate founder in 1913. A small chapel in the Daniel Marsh Chapel is now named for him.

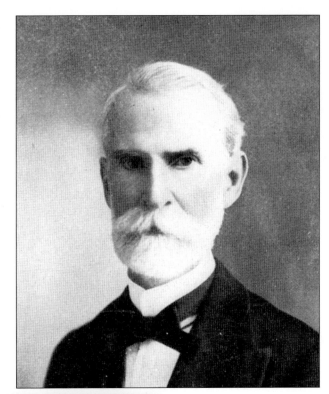

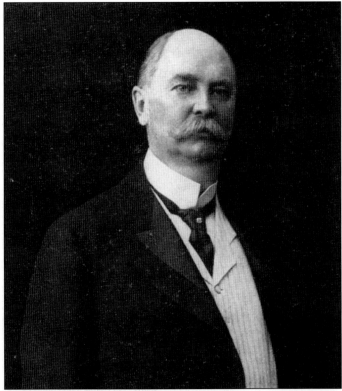

Chester C. Corbin was a trustee from 1892 to 1903. He left part of his estate to the university upon his death in 1903. The rest he left to his wife, Augusta E. (Smith) Corbin, who increased his estate through her wise management of these funds and left another large sum to the university upon her death in 1917. They were both named associate founders in 1918.

61

Alice Stone Blackwell (Class of 1881) was the daughter of Lucy Stone, a noted suffragette. Blackwell continued to edit the *Women's Journal* after her mother's death and was president of the Massachusetts Woman Suffrage Association. Blackwell stands on the left at a suffrage meeting on April 13, 1918, at Coys Hill in West Brookfield. She helped found the League of Women Voters when women achieved the vote in 1920. (Courtesy Schlesinger Library, Harvard University.)

Warren O. Ault became the first full-time professor of history at the College of Liberal Arts in 1913. Ault enlisted in the U.S. Army in 1918 during World War I. He returned to teaching history at the College of Liberal Arts. Ault taught until 1965, wrote a history of the College of Liberal Arts in 1973, and gave his last speech at Boston University in 1989, shortly before his death at 102 years old.

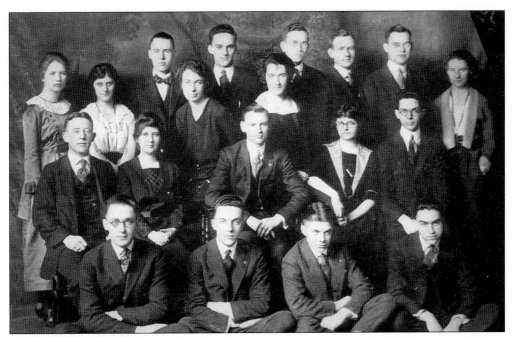

The student council of 1922 met to decide issues about nonacademic affairs and was the liaison between the students and the administration.

Many of the young women attending the university from out of town lived in apartments or rooming houses. The university bought three apartment houses at 332–336 Bay State Road to provide dormitory space for the young ladies. They were occupied in the 1920s, long before classes moved to the Charles River Campus.

Members of the 1920 Girls' Athletic Association are shown here.

There was no course in sociology at the College of Liberal Arts until dean William Marshall Warren, son of the first president, recruited Ernest R. Groves in 1920. Groves (pictured here) taught courses on anthropology, poverty and welfare, and rural and village society. His course on family was probably the first to be offered at any college in the country.

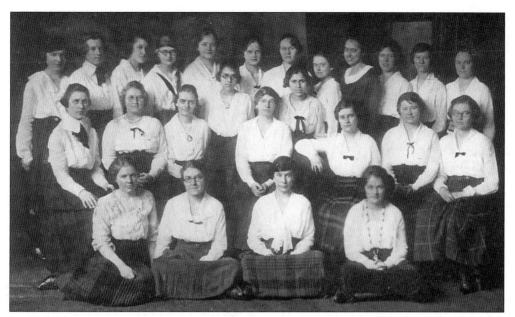

The Kappa Kappa Gamma society was a national sorority founded in 1870. The Phi chapter was established at Boston University in 1882.

Alumni meet on the grounds of the first Nickerson Athletic Field in Weston. Note the knickers the men are wearing (some with argyle socks) and the women with their cloche hats.

The Panhellenic Society of 1923 had representatives from each sorority. They are, from left to right, as follows: (front row) R. Kempl, M. Sale, A. Allan, F. March, G. Elliott, and L. Northrop; (back row) E. Crosby, M. Condon, M. Burdett, R. Fanning, M. Sullivan, M. Hamer, B. Chambers, and M. Nathanson. By 1935, alumnae of the eight sororities rented a house at 131 Commonwealth Avenue for Panhellenic meetings.

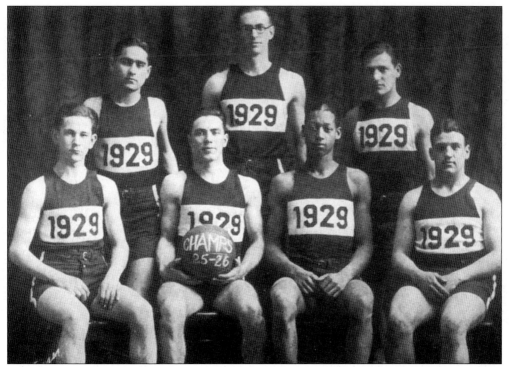

The freshmen had a basketball team in the 1925–1926 season. George B. Emerson was the director of physical education for men during this time. The team used space in the gymnasium on St. Botolph Street.

The 1923 Pan-Adelphic Council consisted of fraternity representatives. They are, from left to right, as follows: (front row) Rosenshine, Kappa Nu; Frank, Tau Delta Phi; Haunton, Kappa Phi Alpha; Thompson, Sigma Tau Epsilon; Wilson, Sigma Alpha Epsilon; Woods, Lambda Chi Alpha; and Hadlock, Chi Sigma Chi; (back row) Thegg, Delta Chi Omega; Lane, Delta Sigma Pi; Whalen, Phi Delta Phi; Northrup, Delta Theta Phi; and Bearg, Zeta Beta Tau.

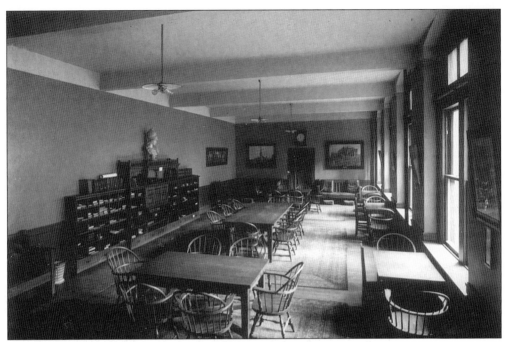

The women were provided with a large study, called the Gamma Delta room, at the rear of the College of Liberal Arts building at 688 Boylston Street. The head of Minerva and the sturdy furniture had been moved from Beacon Hill when the college moved to the Back Bay.

Classics professor Augustus Howe was one of the original faculty members of the College of Liberal Arts. His will and an anonymous gift established a fund in his name to help young men of unusual promise and limited means such as these receive an education.

In 1929, Ledyard W. Sargent became the director of the Sargent School, founded in Cambridge by his father, Dudley Allen Sargent, in 1881 to provide physical education training for young women and a few young men. In 1921, Boston University accepted the gift of the school from Ledyard and Etta Sargent. George K. Makechnie became dean of Sargent College in 1945.

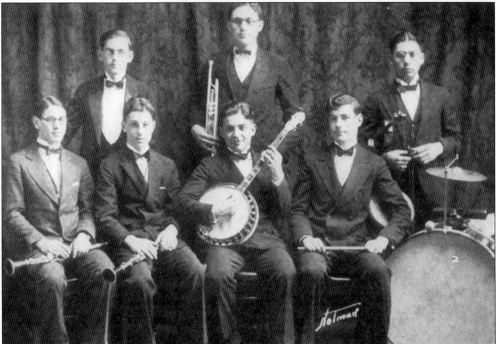

The College of Liberal Arts dance orchestra of 1927 was composed of seven members. They are, from left to right, as follows: (front row) Haskell Ostroff, saxophone; Saul Yafa, saxophone; B. Dobransky, banjo; and Sidney Rosen, drums; (back row) Henry Lasker, piano; Saul Lasseras, cornet; and Albert Pitcoff, violin. Sweet music must have echoed through the halls.

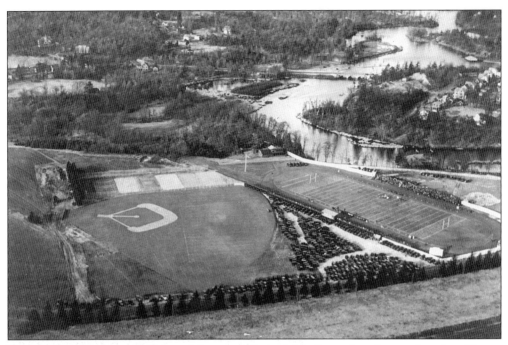

In 1928, in response to the need for an athletic field, the university purchased a 25-acre recreation field from the Boston Athletic Association in Weston, a short ride by train from Copley Square. The field was named Nickerson Field after a generous donor. Many of the sports teams used the clubhouse as their dormitory during the season. Route 128 and the Massachusetts Turnpike now intersect at roughly this spot.

William E. Nickerson was a trustee who enabled the university to buy the field that was named for him. There were adequate facilities for track, tennis, football, and baseball. The land was sold to the Massachusetts Turnpike Authority. The university bought Braves Field in 1954 and renovated it. It became the second Nickerson Field.

Pres. Daniel L. Marsh attended the Boston University School of Theology and then served as a Methodist pastor in the Pittsburgh, Pennsylvania area. He was such an able administrator as the superintendent of more than 100 Methodist churches that the local bishop recommended him as the next president of the university. Marsh served in that post with distinction from 1926 to 1951 and was instrumental in the growth of the Charles River Campus.

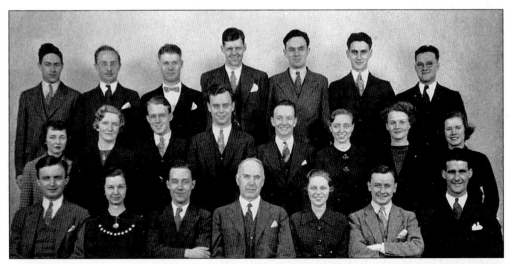

In 1936, the all-university student council consisted of the following, from left to right: (front row) Campbell, Densmore, Kelley, Marsh, Jones, Estes, and Bussell; (middle row) Sweeney, Thanisch, Bond, Lowe, Leary, Kremers, Nickerson, and Thompson; (back row) Tingley, Schatz, Potter, Stone, Cunningham, Lee, and Crummey.

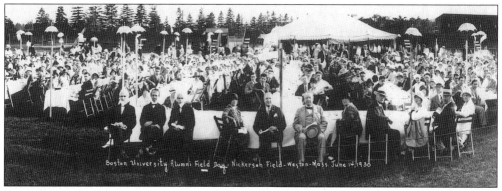

An Alumni Field Day was held at the first Nickerson Athletic Field in 1930. The athletic field served many purposes in addition to its uses for regularly scheduled games with other colleges.

A glimpse of the Soden Building can be seen to the right, behind the College of Liberal Arts building. The university received $145,000 from the estate of Arthur H. Soden in addition to gifts he had made during his lifetime. The property was purchased from the Boston Athletic Association in 1935 to be used by the Graduate School of Arts and Sciences, the College of Music, and the School of Education. It was also used for some College of Liberal Arts classes.

The faculty of the College of Liberal Arts is shown here in 1935. The university faculty remained loyal during the depths of the Great Depression despite several cutbacks in their salaries amounting to nearly 20 percent. There were only a few women among the nearly 50 "officers of instruction" in the College of Liberal Arts.

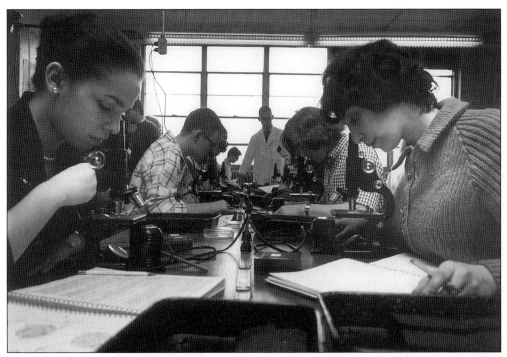

The College of Basic Studies moved into the building at 688 Boylston Street when the College of Liberal Arts moved to the Charles River Campus in 1947. In this March 1961 photograph, College of Basic Studies students are looking intently into their microscopes. Each has a notebook laid out to take down observations.

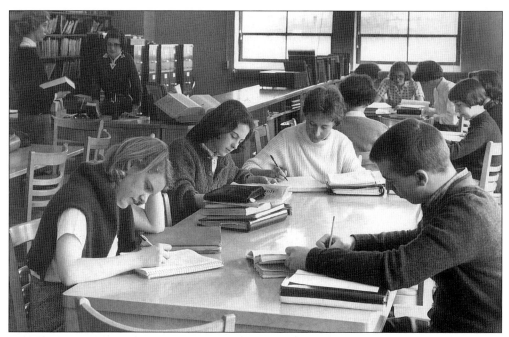

Several students are in the library at the College of Basic Studies on March 8, 1961.

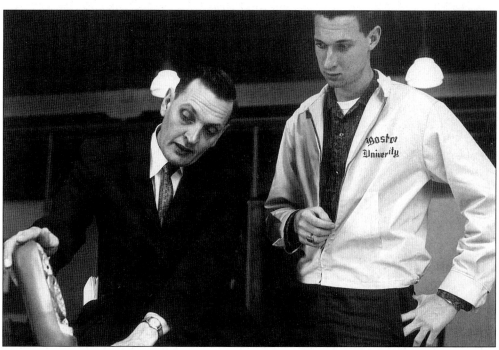

The College of Basic Studies offered a two-year undergraduate program of integrated courses in the humanities, sciences, psychology, and the social sciences. In this May 1961 photograph, Prof. Fred Koss (left) and Carlos A. Ball from Caracas, Venezuela, look at a model together.

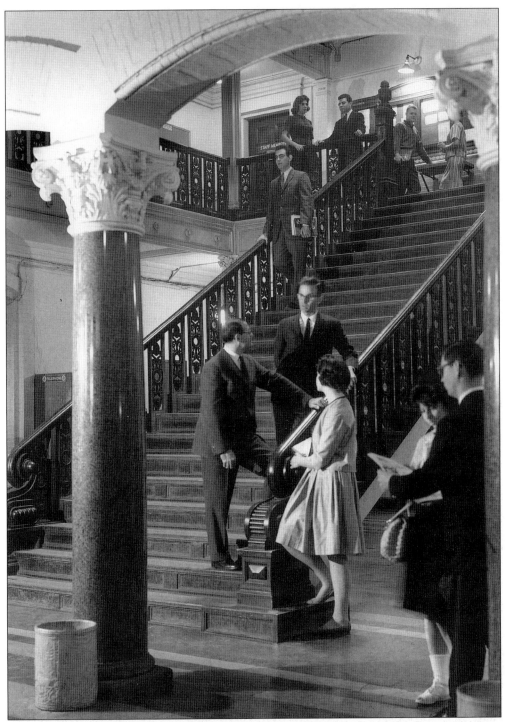

Professors and students gather on May 9, 1962, on the handsome staircase leading to the lobby, referred to as the Marble, at 688 Boylston Street. After the College of Liberal Arts moved to the Charles River Campus, students and professors at the College of Basic Studies used the building before the Boston Public Library bought the property in 1967 for its expansion.

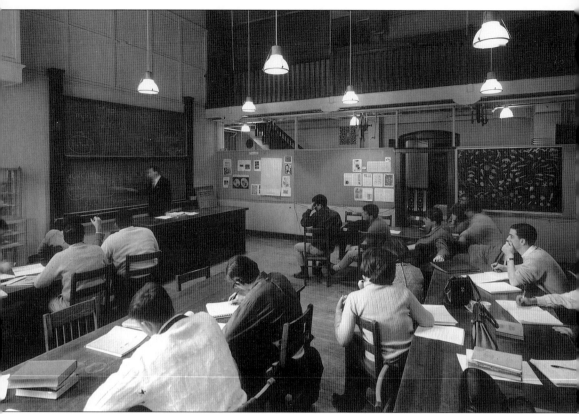

These students appear to be very interested in listening to their science professor. The classroom had been renovated for the College of Basic Studies after the College of Liberal Arts moved to the Charles River Campus. The stairs and corridor of the building can be seen beyond the partition. Note the large chart of the tree of life on the far wall.

Five

BUILDING TO LEARN
1930–1949

The quality of a Boston University education attracted an ever-growing student body. To meet this greater demand, many schools and colleges were compelled to move to larger quarters.

A committee from the board of trustees searched for a central location that would suit the needs of the scattered departments of the university for the next 50 years. Speculators expected to develop houses and apartment buildings on the property to the west of Kenmore Square. When that did not occur, the trustees were able to buy the land relatively cheaply.

The plan of Pres. Lemuel H. Murlin was initiated in 1920 when the trustees bought the land between Commonwealth Avenue and the Charles River and from Granby Street for three fourths of a mile to the west, to what is now University Road. There were 15 acres in all, including the three buildings on Bay State Road already occupied as dormitories. The property was acquired at the bargain rate of less than $4 per square foot for approximately $1.7 million.

Unfortunately, the plans to have an attractive campus stretching along the Charles River did not materialize, as the Metropolitan District Commission took the land along the river by eminent domain, paying the university only about $400,000. From the campus, the river can still be seen across Storrow Drive.

Murlin was not able to fulfill his dream of seeing any structures built on the central campus during his lifetime. His successor, Daniel L. Marsh, was able to raise the money and commission a series of buildings stretching to the west along Commonwealth Avenue. Although they were built at different times, they make a harmonious whole.

Father Beale, from Sandwich, was 100 years old when he attended his 50th reunion on October 22, 1939.

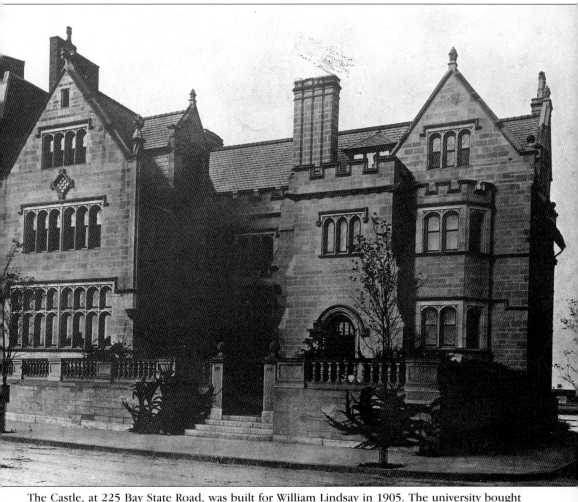

The Castle, at 225 Bay State Road, was built for William Lindsay in 1905. The university bought the property in 1939 for the price of the back taxes with the aid of Oakes Ames and trustee William Chenery. As the home of Boston University presidents Daniel Marsh and Harold C. Case, the mansion was the site of many receptions and entertainments. Although the building plays a similar role today, subsequent presidents have resided elsewhere.

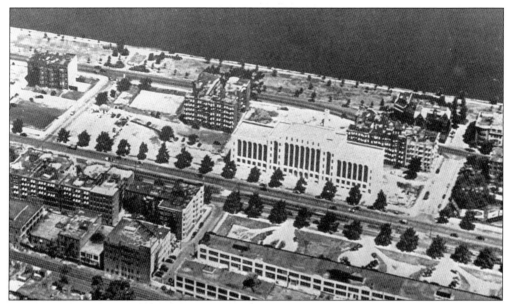

This aerial photograph, taken in 1939 along Commonwealth Avenue, shows the first structure built by the university on its new Charles River Campus. The College of Business Administration moved to the large white building in the center when it had to leave the Back Bay because the Massachusetts Institute of Technology had sold the site to the New England Life Insurance Company.

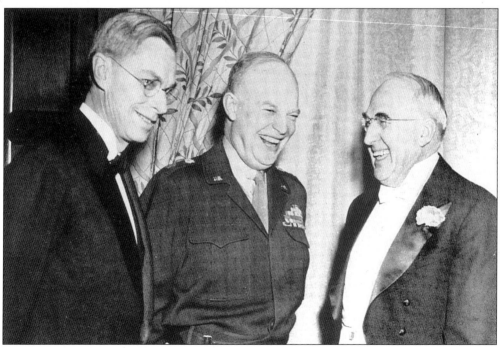

A testimonial dinner was held on January 31, 1946, to honor the 20 years of outstanding service of Daniel L. Marsh as president of the university. Pictured from left to right are James B. Conant of Harvard University, who represented presidents from throughout the country; Gen. Dwight D. Eisenhower; and Marsh. Some $200,000 was raised for the building programs of the university.

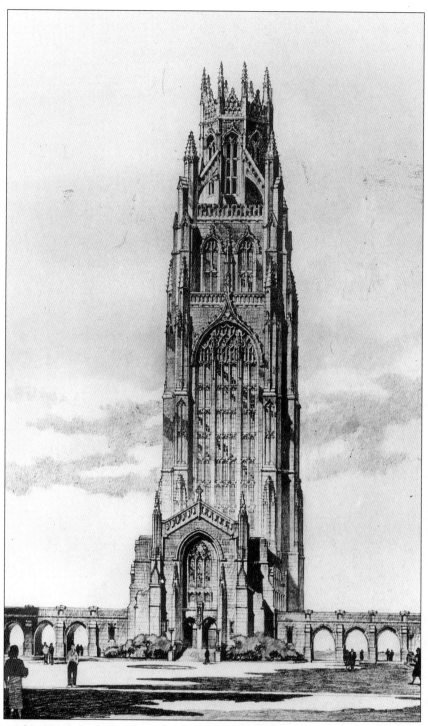

Pres. Daniel L. Marsh hoped to have the Alexander Graham Bell Tower erected behind what is now the Daniel Marsh Chapel. The tower was to be similar to the one at St. Botolph's Church in Boston, England, known as the "Old Boston Stump." Construction began there in the early 1400s and continued for 100 years.

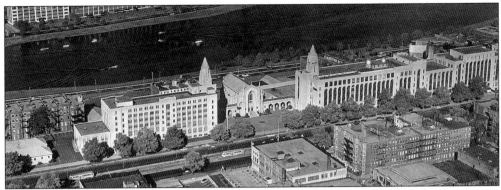

By 1948, the Charles River Campus consisted of several large buildings that contained many of the schools and colleges that had been scattered throughout the Back Bay and Beacon Hill. From left to right are the administrative offices and the School of Theology, built in 1948; the Daniel Marsh Chapel, built in 1949; the College of Liberal Arts, built in 1947; the College of Business Administration, built in 1939; and the Stone Science Center, built in 1948. (Courtesy Bradford Washburn.)

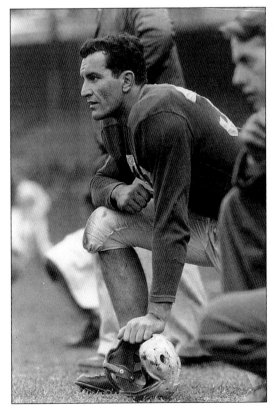

Harry Agganis, known as the "Golden Greek," became a student at the university in 1949. Each year, he played three seasons of sports, football, basketball, and baseball. After serving in Korea, he turned down a bid to play professional football. Instead, he signed a contract in 1952 to play with the Boston Red Sox. Unfortunately, the promising young star died in 1955.

Six

LEARNING ON THE NEW CAMPUS 1950–1959

By the 1950s, the first structures planned for the Charles River Campus along Commonwealth Avenue had been built with the Daniel Marsh Chapel in the middle. The university also owned many of the existing buildings along Bay State Road.

Now the university began to expand its facilities through adaptive reuse. For example, a building at the corner of the Boston University Bridge and Commonwealth Avenue was built as a Buick showroom but is now used by the College of Fine Arts.

The land at the first Nickerson Field in Weston was taken by the Massachusetts Turnpike Authority, and the university was able to acquire Braves Field, close to the main campus, when the Boston Braves franchise moved to Milwaukee. Most of the stands were later demolished.

As more dormitory space became available and fewer students commuted, students were interested in a wider variety of activities and organizations.

With more students living on campus, the administration felt that it had to act in place of the parents. Alcohol and gambling were strictly forbidden. The dress code required that the women wear skirts and the men wear jackets and ties.

On the whole, the 1950s were a peaceful time on campus. The goal of the students was to receive an education and then get on with their lives. Women had always been accepted at all of the schools and colleges. Although some went on to graduate school and careers, others stayed at home to care for their families.

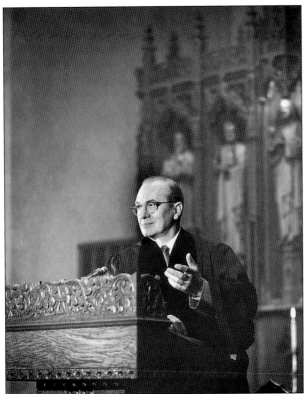

Harold C. Case served as the president of the university from 1950 to 1967. During his administration, the size of the campus increased from 15 to 45 acres, and the number of buildings increased from 28 to 91. The George Sherman Student Union, the Mugar Memorial Library, and Nickerson Field were added during this period. The budget and endowment grew steadily.

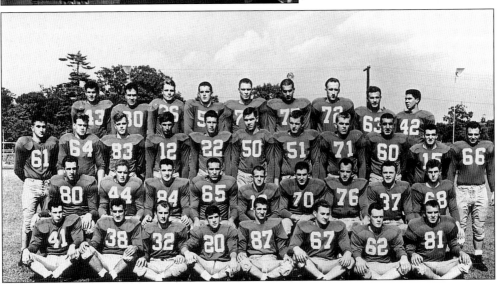

Members of the varsity football team pose in 1951. Identified by last name, they are, from left to right, as follows: (first row) Winkleman, Pino, Taylor, Nunziato, Landon, Cataloni, Keane, and Meredith; (second row) Capuano, Mahoney, Oates, Barbagallo, Hanson, Czerapowitz, Miller, Kastan, and Donahue; (third row) Mavropoulos, Sweetland, Strom, Schulz, Cahill, Hurstak, Gracie, Dobias, D'Errico, Cataldi, and Berg; (fourth row) Luciano, Moriello, Haden, Pappas, Fraser, Vendetti, Pedneault, Maiuri, and DeFeudis. Absent from this photograph are Agganis, Petroka, Wallace, and manager Zingus.

Scarlet Key is an honorary society of students who have achieved good grades and have displayed qualities of leadership. The Annual Awards Night was held in 1951 at the Castle, the home of Pres. Harold C. Case and his wife. The young ladies wore strapless bouffant dresses in the style of the day, and the gentlemen wore tuxedos.

John Simson entered the School of Education in fall 1946 after World War II and played varsity football at the first Nickerson Field. Simson was the first athlete to be accepted to the Scarlet Key. The secretary, Dorothy Porteri (his future wife), wrote to invite him to the second meeting. They attended the senior prom at the Copley Plaza. Simson returned to the university to serve as the athletic director from 1975 to 1984.

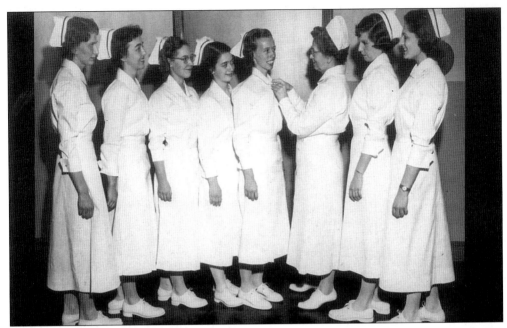

In this January 1952 ceremony, seven students at the School of Nursing receive the pins that designate them as registered nurses. In autumn 1946, the School of Nursing (now closed) had been separated from the School of Education, where it had existed as the Division of Nursing Education for some years.

The B'nai B'rith Hillel Foundation raised money to construct a building in 1953 for the use of the Jewish students on campus. A handsome sight was chosen at 233 Bay State Road for the triangular building that backed up to the Castle. Constructed of limestone, the structure overlooks the Charles River.

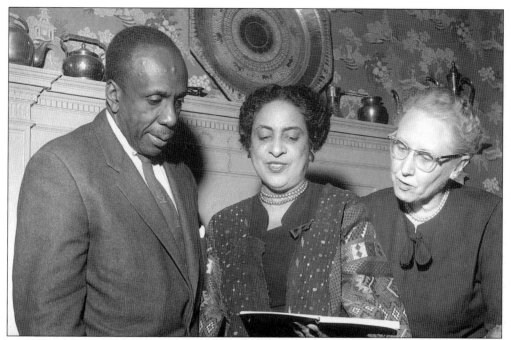

Seen together at 184 Bay State Road are, from left to right, Howard Thurman, dean of the Daniel Marsh Chapel from 1953 to 1965; Sue Bailey Thurman; and Elsbeth Melville (College of Liberal Arts, 1925), dean of women. Howard Thurman was the first black dean in the country at a predominately white college.

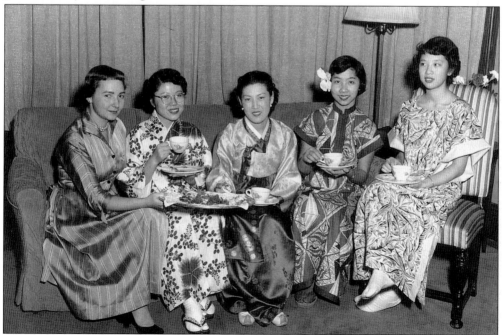

A tea was held on December 16, 1953, at the Harriet E. Richards Cooperative House at 191 Bay State Road for international women students and wives. Students have come to the university from around the world since it was chartered in 1869.

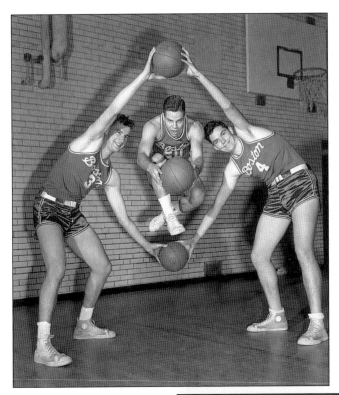

Three members of the 1953 Boston Terrier men's basketball team execute a tricky maneuver at the Boston Latin School gym in the Fenway. Tom Alcock (left) and Kevin Thomas (right) hold two basketballs while they make a circle with their arms for teammate Don Russell to jump through.

Martin Luther King Jr. received his doctorate from the Graduate School of Arts and Sciences in 1955. His studies included American Personalism, a philosophy formulated early in the century by Boston University professor Borden Parker Bowne. The philosophy held that the cosmic moral law was innate in all humans; thus, slavery and segregation were wrong and all individuals were obligated to oppose them. King returned south and would credit the development of his philosophy to his Boston University professors.

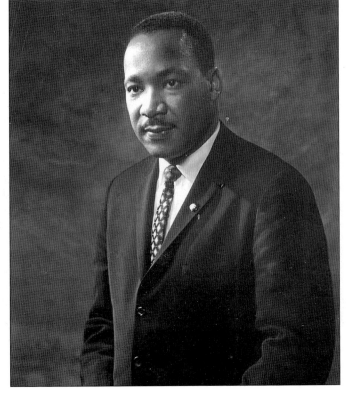

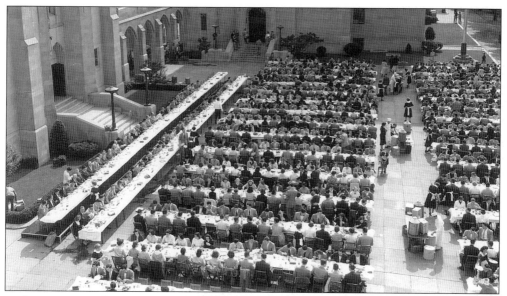

In this May 1953 photograph, new graduates and alumni enjoy breakfast together on the plaza in front of the Daniel Marsh Chapel.

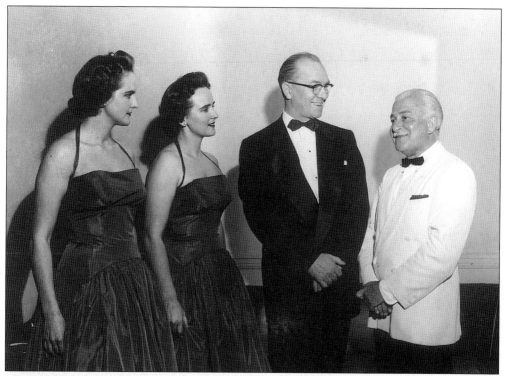

The Gutberg twins, Ingrid and Kari, played a Mozart piano concerto at the Boston University Night at the Pops on May 31, 1957. The sisters were doctoral candidates at the School for the Arts. Seen here are, from left to right, the twins; Pres. Harold C. Case; and Arthur Fiedler, who conducted the orchestra at Boston Symphony Hall on this festive evening.

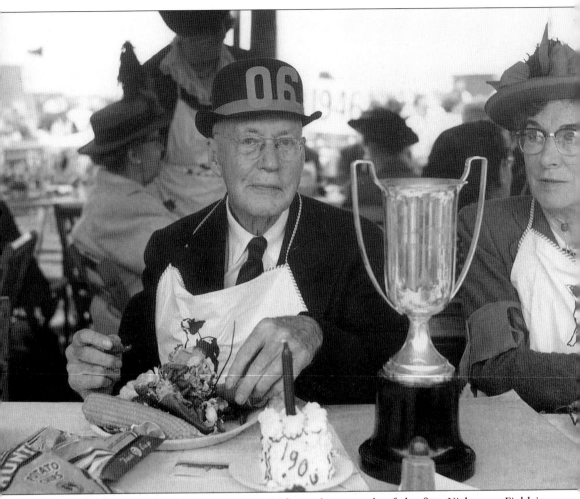

The alumni enjoyed a feast on June 2, 1956, on the grounds of the first Nickerson Field in Weston. Here, a member of the Class of 1906 celebrates his 50th reunion by eating a typical New England summertime meal of lobster, corn on the cob, and potato chips, along with a special cake with a candle and the date that he graduated.

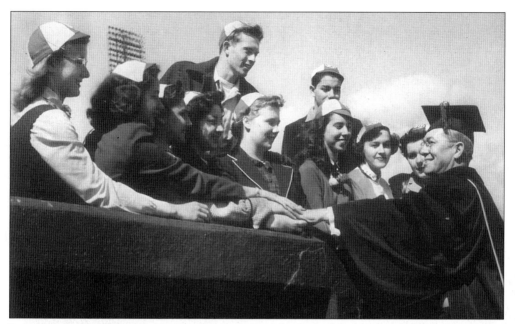

Pres. Harold C. Case greets the freshmen students in their red-and-white beanies, which they wore for a few weeks at the beginning of the year. During his 17-year tenure, the president improved the lives of the students with the building of the George Sherman Union and the Mugar Library.

An informal atmosphere prevails in the lounge of the College of General Education.

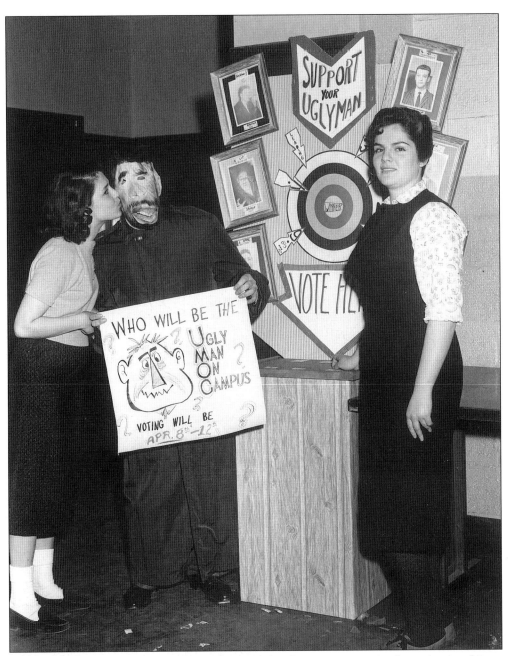

Men from the entire university could belong to Alpha Phi Omega, a service fraternity. At a fair on April 8, 1957, the students were asked, "Who will be the Ugly Man on Campus?" In this view, Elaine Kaplan (College of Business Administration, from Newton) kisses "Ugly Man" Jason Hoffman (College of Business Administration, from Chelsea), while Riza Gross (College of Liberal Arts, from Hillside, New Jersey) stands by.

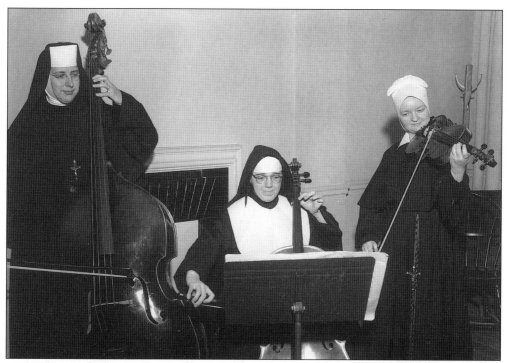

These nuns studied music at the School of Fine and Applied Arts. The photograph was taken on August 2, 1957, when the school was at the corner of Exeter and Newbury Streets in the Back Bay. The nuns must have made heavenly music.

Dean George K. Makechnie (School of Education, 1929, 1931) bids goodbye to the Sargent College building at 16 Everett Street in Cambridge on June 24, 1958.

A Christmas-Hanukkah sing was held in the Daniel Marsh Chapel on December 17, 1957. Phyllis Kirk Case, wife of the president, spoke at the service. Although she was a licensed Methodist preacher, she never held a position in a church but devoted her life to her husband's work.

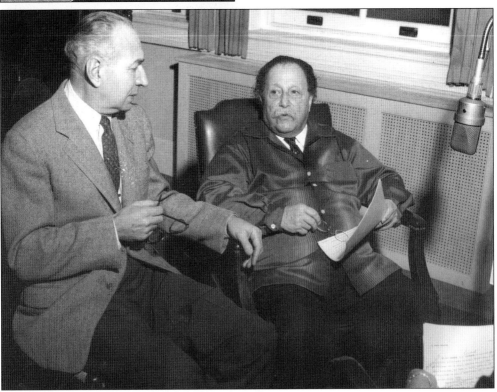

Pierre Monteux and Louis Spier are shown making a recording in the greenroom at Boston Symphony Hall for a program on the university radio station WBUR on January 7, 1958. Pierre Monteux conducted the Boston Symphony Orchestra from 1919 to 1924.

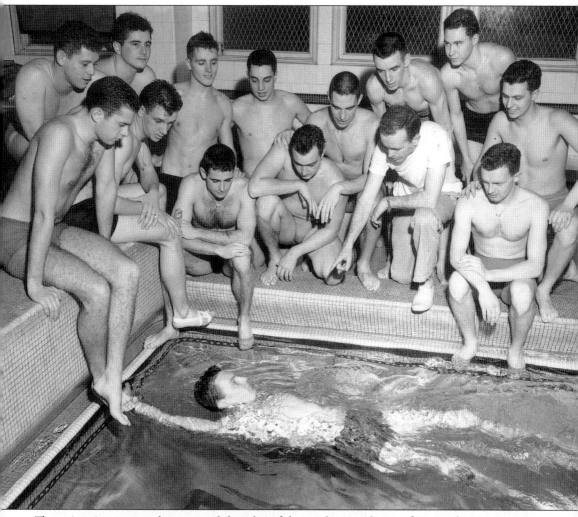

The swimming team gathers around the edge of the pool to watch one of its members execute a backstroke in February 1953 at the private University Club on Stuart Street. Until the Case Athletic Center was built in 1972, the sports teams used rented space throughout the city for their programs.

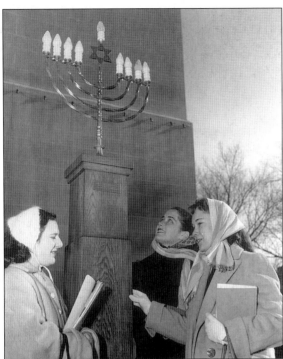

Many signs of the approaching holidays were displayed throughout the campus. In this photograph, taken on December 13, 1957, three girls view the menorah displayed atop a pedestal during Hanukkah.

Registration days in the fall include a variety of activities, and buying course books is one of them. Taken in front of the Boston University Bookstore and Supply Shop, this 1958 photograph shows, from left to right, Terrie Casden, Ann Machtinger, and Judy Jameston.

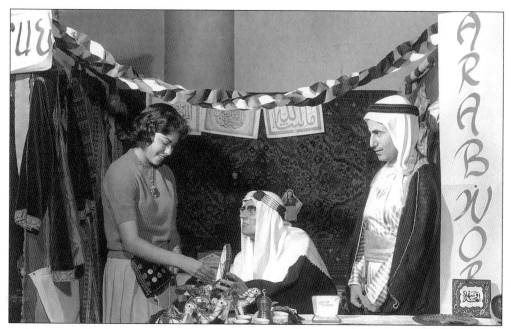

An international students event at the School of Fine and Applied Arts was held in October 1958. It was an opportunity for students from many foreign countries to display the products of their native lands. Pictured here is the Arab World booth.

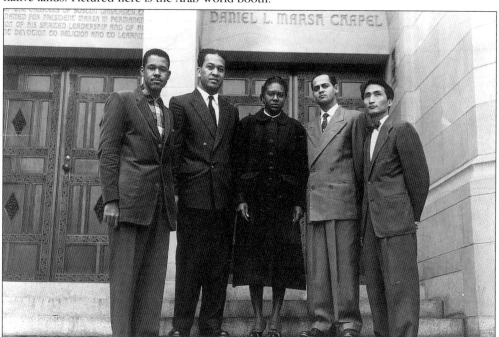

Several students received scholarships from the Methodist Conference every year. Some of these Methodist scholars are shown on the steps of the Daniel Marsh Chapel in 1958. Although the university is nondenominational, the School of Theology continues to include a Methodist seminary. Also, the Methodist Church takes an interest in the university, since the three founding fathers were devout Methodists.

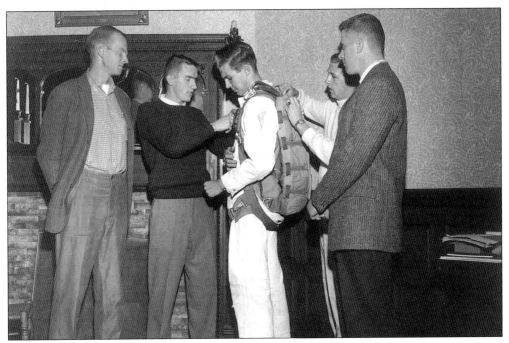

The all-university Parachute Club met at 71 Mountfort Street. In a university of this size, there were many student organizations that appealed to a variety of interests. Some members of the Parachute Club are shown here on November 20, 1958.

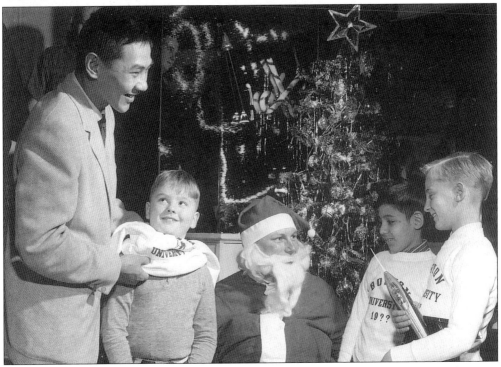

In 1958, the student government board of the Myles Standish dormitory sponsored a Christmas party for a group of boys. Arthur Yuan (left), a student from Formosa, was chairman of the event.

Students are pictured at the March 4, 1959 tryouts for stunt night at Hayden Hall at the College of Business Administration. The hall, completely renovated thanks to a gift from alumnus Gerald Tsai, is now called the Tsai Performance Center and is the site of many concerts and other events.

On September 16, 1959, Morris Springer became a new student at the age of 89. He bought the books required for his courses and undoubtedly wondered how he was going to carry them all home. The bookstore was located in the basement of the College of Liberal Arts.

Harold Russell (College of Business Administration, 1949), who lost both hands in World War II, won two Oscars in 1946 for his supporting role in *The Best Years of Our Lives.* He is shown here on February 11, 1959, planning a "rehabilitation film" with Pres. Harold C. Case's son Robert, who was deaf and was the first director of Photo Services.

Two Hawaiian students decorate the Christmas tree on December 18, 1959, at the Towers residence hall, on Bay State Road.

Seven

A Different Kind
of Learning
1960–1979

The presidency of Harold C. Case (1950–1967) was a time of growth for the university. New structures were built in quick succession: the Law-Education Tower in 1961 and three new dormitories on the western edge of Nickerson Field—Claflin, Sleeper, and Rich Halls. The Warren Towers complex was built in 1965 at 700 Commonwealth Avenue opposite the original Gothic buildings of the Charles River Campus.

After 10 years of careful planning, the George Sherman Union was built in 1963 to serve the needs of the students. It contained a dining facility and was the center of a variety of activities. The Mugar Memorial Library was dedicated in 1966, and Special Collections continued to acquire its 20th-century archives of books, manuscripts, and ephemera.

More schools and colleges moved onto the Charles River Campus, extending its dimensions. The College of Engineering arrived in 1963, and Metropolitan College assumed the role of the Division of Continuing Education in 1965. In 1966, the College of Basic Studies moved from Copley Square. The first graduate school of dentistry in the country was opened at the Boston Medical Center in 1963.

The 1960s started peacefully. There was a feeling of optimism as John F. Kennedy took office as president of the country. Events in the nation and the world changed that attitude.

The Civil Rights movement was gaining strength. One of the primary leaders was Martin Luther King Jr., who had graduated from the Graduate School of Arts and Sciences doctoral program in 1955.

In the mid-1960s, students began antiwar demonstrations. Throughout the later 1960s and 1970s, there were protests and counter-protests against our national policies and those on campus. In spring 1970, fires were set on campus, and final exams and graduation were cancelled. Arland Christ-Janer, president since 1967, resigned.

John Silber became president in 1971. He accomplished his plans to increase the endowment, bring more outstanding professors to the faculty, and balance the budget.

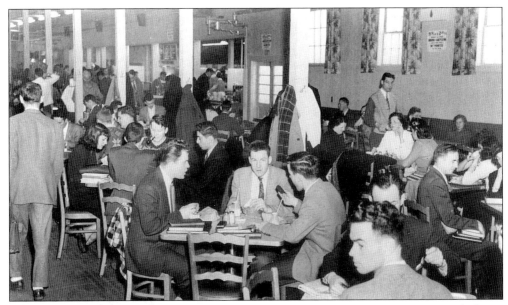

Students dine in the old Commons in 1960, before the George Sherman Union eating hall was built in 1963. The Commons, the central cafeteria of the school, was situated in a block-long World War II army surplus building that stretched from behind the College of Business Administration toward the Charles River.

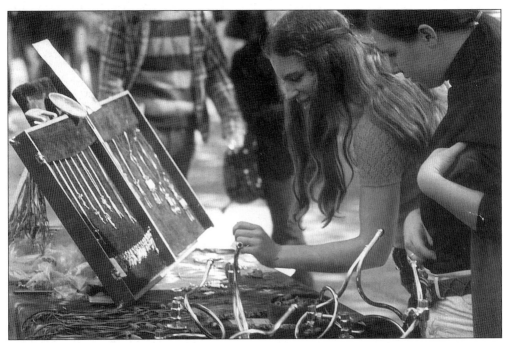

When the weather was favorable, hawkers would set up tables with their wares on the sidewalk along Commonwealth Avenue. In this 1960s view, a display of jewelry and other merchandise intrigues two students.

Cheerleader Diane E. Etienne (now Faxon) holds the mascot of the university, the Boston terrier, in her megaphone at the Boston University–George Washington football game on October 15, 1960. She was a student at the School of Nursing in the Class of 1961.

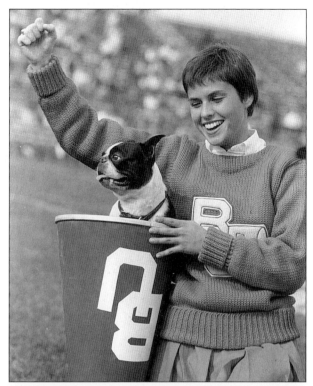

Three students check into the Towers residential hall on January 3, 1960, after their winter break. The girls will soon be telling one another about their vacations.

Faye Dunaway appeared in *Cock-a-Doodle-Dandy* while she was a student at the School of Fine and Applied Arts. This dress rehearsal took place on October 31, 1961. After Dunaway graduated, she went on to a successful career in film and on the stage.

A Danish gymnast, shown on the right, teaches a modern dance to six students at the Sargent College of Physical Education on November 13, 1961.

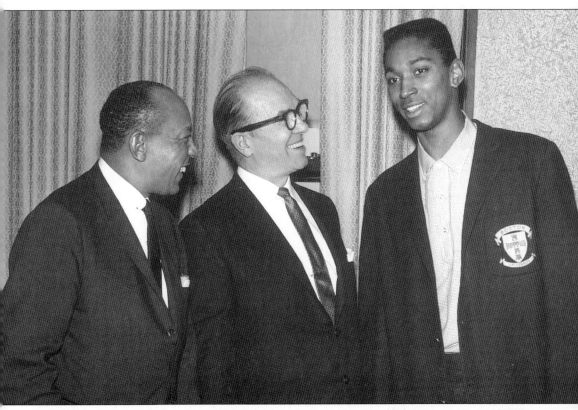

Runner Jesse Owens (left), who won four gold medals in the 1936 Olympics, is pictured with Pres. Harold C. Case (center) and sophomore John Thomas. While a freshman at Boston University in 1959, Thomas became the first man to jump seven feet indoors. He went on to become a two-time Olympic medalist (1960 and 1964) and later returned to his alma mater to coach.

Seen across the river, a tall modern structure was built to house both the Schools of Law and Education in 1961. The School of Law moved from 11 Ashburton Place on Beacon Hill to this site at 765 Commonwealth Avenue. The School of Education moved in 1980 to 605 Commonwealth Avenue at the corner of Sherborn Street.

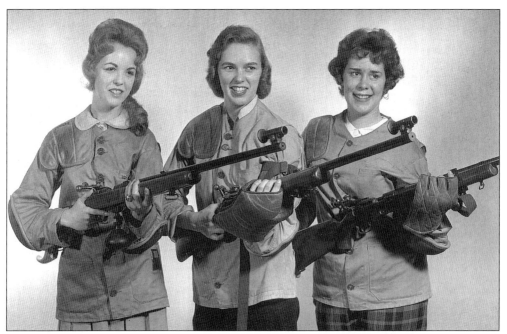

The women's rifle team did very well in competition. Shown in May 1961, these markswomen are, from left to right, Andrews, Kilb, and Smith. The Pershing Rifles, an all-university organization for both men and women, was intended to promote fellowship between the students and the Reserve Officers Training Corps (ROTC) army officers.

John DeLuca, a student in the Division of Continuing Education, enjoys breakfast with his family at 345 Commercial Street in Weymouth on January 31, 1962, before he leaves for work.

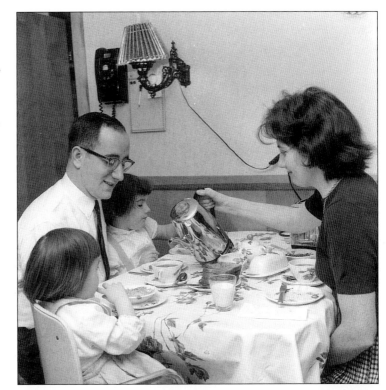

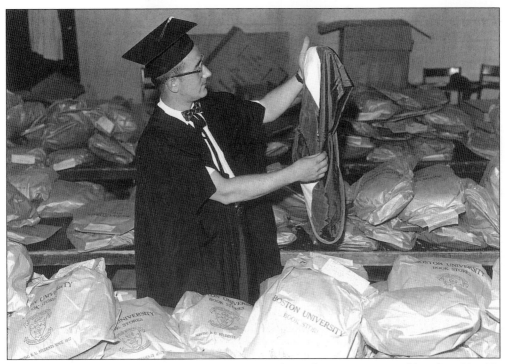

Having finished his course of study, John DeLuca picks up his cap, gown, and hood on May 28, 1962, at the bookstore.

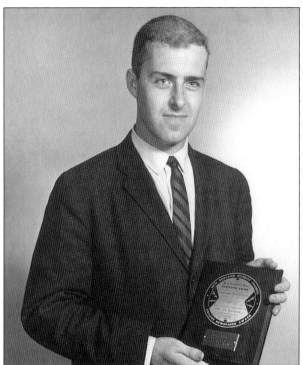

David Bickford was a columnist for the *Boston University News.* In July 1962, as editor in chief, he accepted an award given by the New England District Council of the American Newspaper Guild. The award recognized the *Boston University News* as the best college newspaper in New England.

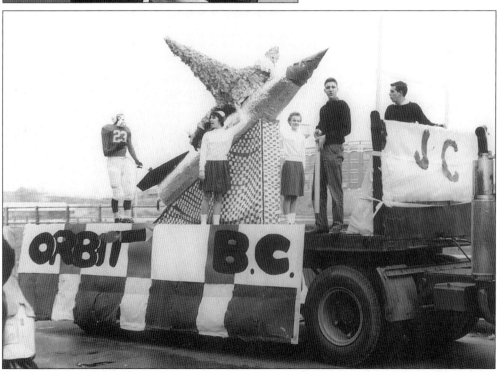

In a homecoming parade in the late 1950s, a float makes its way along Commonwealth Avenue, marking two important events—the launch of the world's first artificial satellite, *Sputnik,* and that afternoon's football game against Boston College.

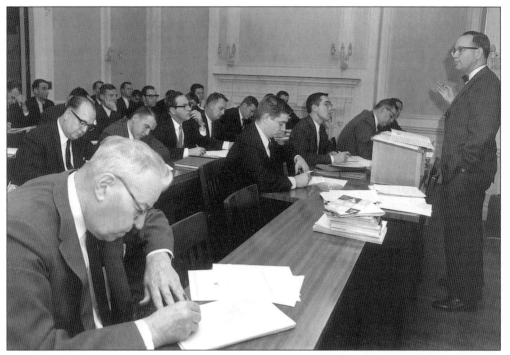

A stock exchange class in the College of Business Administration is being led by Prof. Van Dyke Burhans on January 4, 1962, at the handsome Seminar Center at 152 Bay State Road, on the corner of Sherborn Street. There had been evening and Saturday classes in various schools before the introduction of the Division of Continuing Education, which led to the development of Metropolitan College.

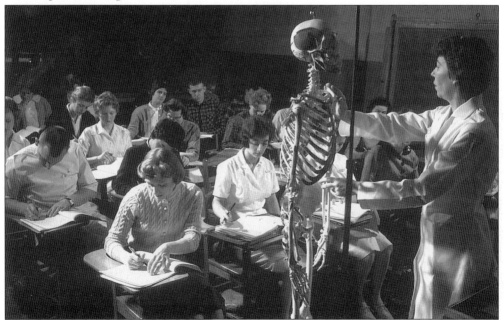

A physical education teacher uses a skeleton to make her point in March 1962. The students seem intent on the subject as they learn about the internal structure of the body.

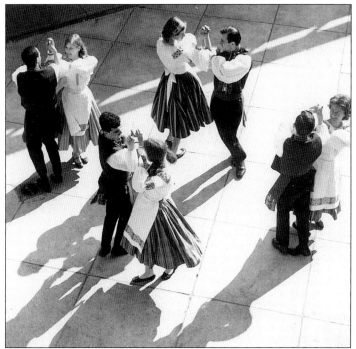

The goal of the Folk Dance Club was to provide wholesome recreation and a culturally broadening activity to the university students. Under the leadership of Prof. E. Eddy Nadel, the students became familiar with the folk music and dances of America and other countries and enjoyed a good workout.

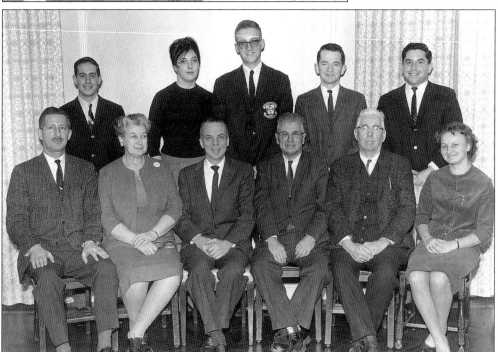

The governing board for student publications is shown at the Faculty Club on February 6, 1963. From left to right are the following: (front row) Prof. R.B. Aram; E. Collier; Dr. J.W. Yeo, chairman; unidentified; Prof. P. Bunker; and M. Magiera; (back row) S. Fromm; G. Sclar; R. Roffman; L. McCarthy; and J. Kaplan. Absent from this picture are D. Bickford; N. Gray, alumni representative; and N. Waksler.

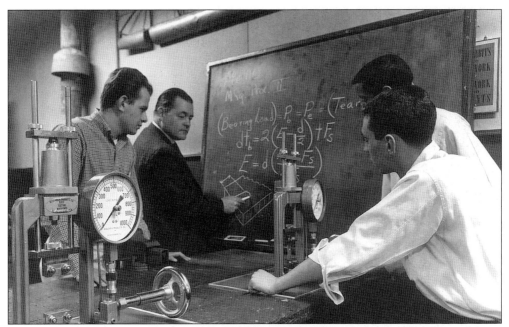

The College of Industrial Technology (the future College of Engineering) was located at Logan Airport in East Boston. The school offered studies in aeronautics, leading to an associate's or bachelor's degree. The course led to credit in the Division of Continuing Education or the College of Industrial Technology. In this photograph, taken on February 25, 1963, students meet in the Manufacturing Process Laboratory.

Albert V. Danielsen's life was similar to that of the three founders of the university. He was orphaned and began to work at an early age. While attending night school, he became a bond salesman and invested his profits in real estate. He and his wife, Jesse, established the Danielsen Fund charitable trust and founded the Danielsen Institute for Pastoral Counseling at the School of Theology. He was named an associate founder in 1964.

A bowling tournament was held in the George Sherman Union at 775 Commonwealth Avenue, where there were 10 alleys in the basement. The union had opened in 1963 and fulfilled the need to have a central building with a variety of restaurants, lounges, and rooms for various activities. Several student organizations were also located in the building.

In December 1965, students listen intently to the teacher while taking notes.

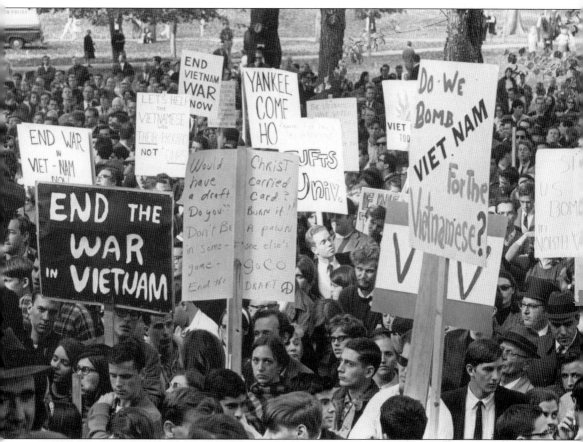

Unrest about various social issues swept the college campuses in the 1960s and 1970s. One of the major concerns was the war in Vietnam. There were various forms of protest against the war, including sit-ins, teach-ins, and leafleting. In October 1965, a mass demonstration of students and others was held on the Boston Common, where many young men burned their draft cards.

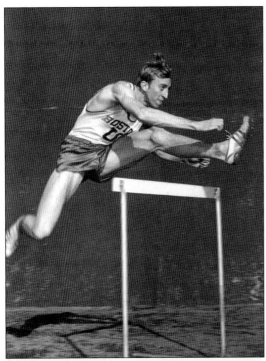

In 1965, Dane Hemerey was a member of the track-and-field team, where he specialized in the 400-meter hurdles. He returned to England to represent his homeland at the 1968 summer Olympics (held in Mexico), where he won a gold medal. At the 1972 Olympics, he received silver and bronze medals. He earned degrees from Boston University in 1968 and 1988 and was inducted into the Boston University Hall of Fame.

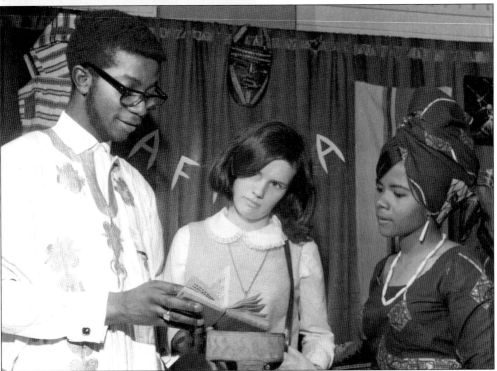

A Festival of All Nations was held in the ballroom of the George Sherman Union at 775 Commonwealth Avenue in 1965. International students demonstrated the products, art, and food of their homelands.

A couple holds hands while strolling along Commonwealth Avenue in the mid-1960s.

Vietnamese students on campus published a newspaper called *Giao-Dan* in their language for the local colleges. Posing in March 1963 are, from left to right, Pho Ba Hai, Phi Minh Tam (secretary), Nguyen Van Nghia, Le Manh Hung, unidentified, Nam Hai, Stephanie Flowers, and Tran Kiem Khiet (general secretary).

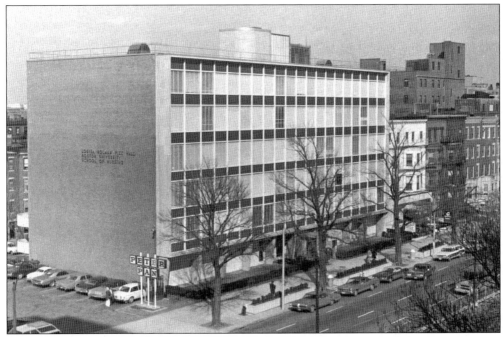

The School of Nursing was established in 1946. The school introduced the first bachelor's degree nursing program in the Commonwealth. In 1969, the Boston University Women's Council donated more than $500,000 for renovation of a building at 635 Commonwealth Avenue for the school.

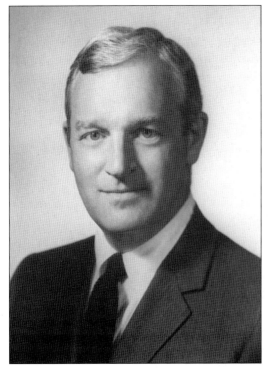

In 1967, Arland Christ-Janer became Boston University's first president who was not a clergyman, although he had graduated from a divinity school. He moved from the presidency of a country college of 1,000 to a city university of 19,000 at a time of great turmoil. The demonstrations made the administration of this affable, student-oriented man most difficult. He resigned in 1970.

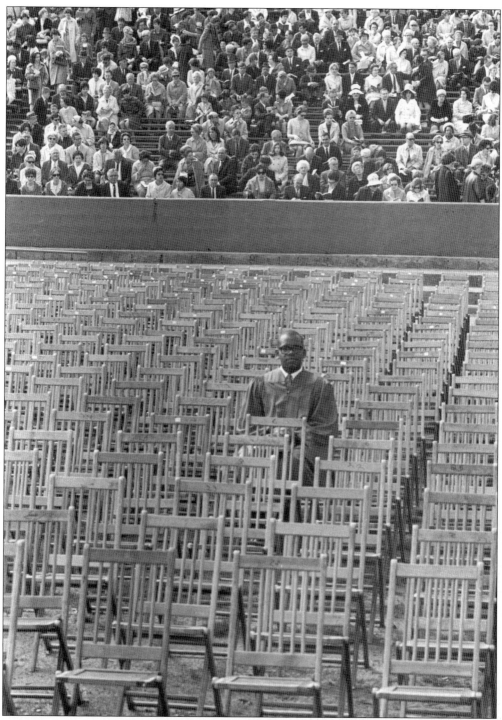

Coleridge Gill was the first graduate of Metropolitan College (MET) in 1967. He received a bachelor's degree in applied science. After the ceremony, he remarked, "I knew that I could write off class reunions." Situated at 755 Commonwealth Avenue, MET opened in 1965 with the purpose of educating the working adult at nontraditional times.

The coeducational Boston University Dingy Sailors (BUDS) won national titles in 1982, 1985, and 1999.

Bruce Taylor, defensive back for the Terrier football team from 1967 to 1969, was a first-round draft pick for the San Francisco '49ers and a 1971 Pro Bowl selection. He graduated in 1970.

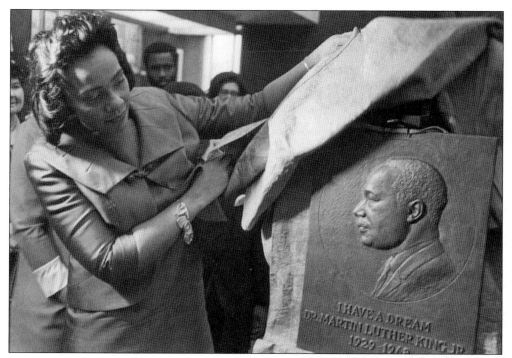

On Founders Day, March 13, 1969, Coretta Scott King received an honorary degree, gave a convocation address, and unveiled a bas-relief of her husband. The bas-relief was done by Bashka Paeff, the wife of Prof. Samuel Waxman.

George Wald, who won the 1967 Nobel Prize in Medicine, speaks at a seminar in Jacob Sleeper Hall, at 855 Commonwealth Avenue, in December 1969. The College of Basic Studies had moved to the renovated building from Boylston Street in 1964. This was the third auditorium to be named after Sleeper, one of the three founders.

Calvin B.T. Lee became dean of the College of Liberal Arts in 1969. He served as acting president of the university from 1970 to 1971, following Pres. Arland Christ-Janer's resignation.

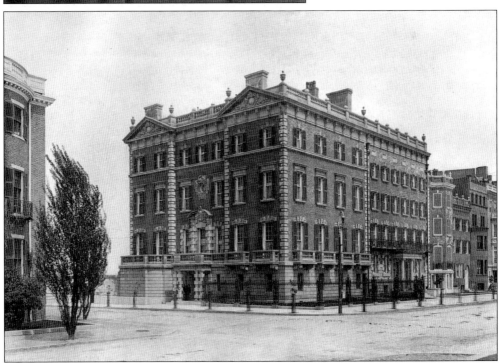

One of the most imposing buildings on Bay State Road is the former Weld mansion. The mansion was built in 1900 for the prominent surgeon William Weld. The university acquired the building from its second owner in 1941. This photograph dates from c. 1903.

John Silber is a native of Texas, where he attended college. He received a doctor of philosophy degree from Yale and taught there for a few years before joining the University of Texas Department of Philosophy, becoming chairman of the department and then dean of the College of Arts and Sciences. From 1971 to 1996, he served as the seventh president of Boston University. He then became the chancellor. Under his leadership, the university acquired financial stability, established the highest standards for faculty recruitment, and developed dozens of new academic and research programs, reaching the first rank of the world universities.

Mugar Memorial Library, at 771 Commonwealth Avenue, was dedicated to the memory of Sakis and Vosgitel Mugar by their son Stephen Mugar. Shown in front of the building are several bicycles, a popular means of transportation in addition to the trolley and cars. Parking has been a constant source of aggravation at this urban school.

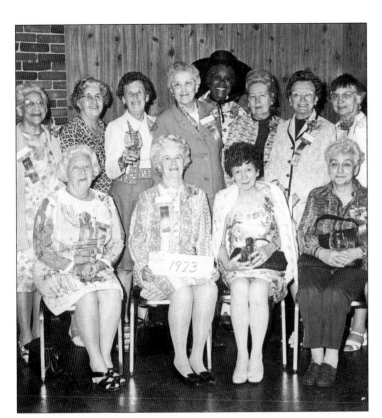

Several women gather for their 50th reunion.

Boston University students are shown in front of the George Sherman Union.

Eight

KNOWLEDGE EXPANDS
1980–2001

By the beginning of the 21st century, the School of Hospitality Administration and the School of Public Health had separated from, respectively, Metropolitan College and the School of Medicine to become independent. New institutes and centers were founded. As structures near the Charles River Campus had become available, they were purchased and renovated. Apartment-style residence halls were built at 10 Buick Street, just off Commonwealth Avenue.

The students engaged in a number of different sports. Varsity football was eliminated in 1997, but the homecoming parade, with its ingenious floats, continued. The first women's varsity team was established in 1973 with crew. From then on, the variety of women's varsity sports increased.

Sculpture, small parks with benches, and seasonal plantings were added on the campus, which stretched along three major thoroughfares—Storrow Drive, Commonwealth Avenue, and the Massachusetts Turnpike. Students lived in dormitories of various types and sizes or commuted, often by trolley; others used the trolleys to move from one end of campus to the other.

Students continued to arrive from numerous countries and cultures. In many years, the university had the greatest number of countries represented of any college in the country.

The Huntington Theatre Company, a professional company in residence, was established in 1982 and housed at the Boston University Theatre on Huntington Avenue. College of Fine Arts students continued to use the building for their productions. Henry Jewett, leading man in the company for which the theater was built in 1925, continued to haunt it.

Kathryn Silber (left), wife of Chancellor John Silber, chats with Bert Hirshberg, program chairman, at the annual meeting of the Boston University Women's Council. Founded in 1925, the council led in establishing the Department of the Dean of Women. The council maintains a house at 146 Commonwealth Avenue, where 16 graduate women students live. The council awards several scholarships and holds monthly meetings at the house.

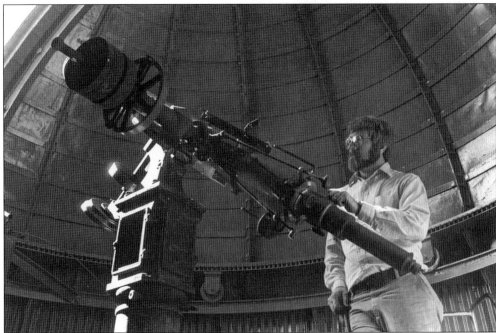

Jeffrey Baumgardner is shown in the Judson B. Coit Memorial Observatory on the roof of the College of Liberal Arts in 1981. Baumgardner received his bachelor's and master's degrees from Boston University in 1970 and 1977. In 1978, he became the curator of the observatory and planetarium at 725 Commonwealth Avenue.

The Huntington Theatre Company has allowed students and graduates to work with a professional company both on stage and behind the scenes. The 2000 production of *Dead End,* by Sidney Kingsley, was directed by Nicholas Martin, who is also a professor of theatre arts at the College of Fine Arts. Boston University graduate Dennis Staroselski is third from the left, and Boston University student Keith Elijah is fourth from the left.

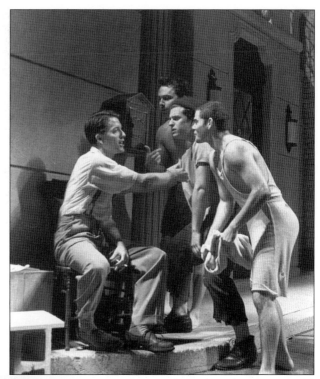

On February 25, 1979, Humberto Cardinal Medeiros (left)—assisted by the university's Catholic chaplain, Fr. Donald Baxter—celebrated mass at the Daniel Marsh Chapel. The music was a mass composed by Norman Dello Joio, the dean of the College of Fine Arts.

Bruce B. Kydd graduated from the College of Communication in May 1991. Celebrating this milestone are, from left to right, Bruce; his brother Brian; his mother, Sally Ann Kydd, who received degrees from the School of Education (1958) and from the Graduate School of Arts and Sciences (1977); and his father, Richard B. Kydd, who received degrees from the College of Business Administration (1953) and the School of Law (1956).

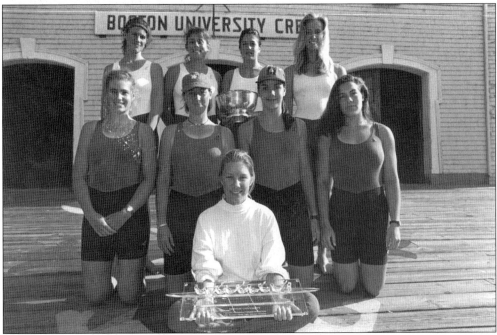

Members of the varsity crew team display their trophies on the dock of the old boathouse after having won the 1992 National Championship. They are, from left to right, as follows: (front row) coxswain Melissa Hall, holding a trophy; (middle row) Sara Field; Portia Gray; Carrell Gridley; and Amy Turner; (back row) Kelly Musick; Sue Charles; Sarah Baker, holding the silver bowl; and Tina Farbaniec.

Jon Westling graduated from Reed College, was a Rhodes Scholar, was active in the Civil Rights movement, and served in several Boston University positions, including provost and acting president, before he became the eighth president of the university, in June 1996. In the first years of his tenure, major buildings were completed for the School of Management and for photonics research. Also, the Student Village began, and the Division of Extended Education was created to expand nondegree professional training, off-campus live and computer-taught courses, and other nontraditional education.

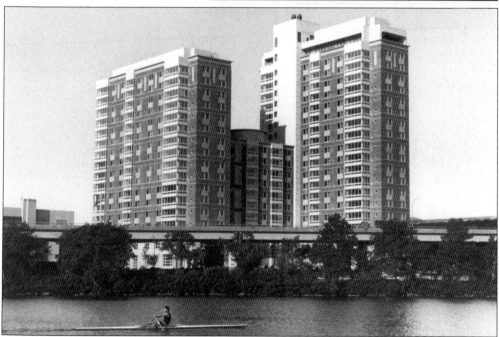

The Student Village, located at 10 Buick Street, opened in 2000 with the latest dormitory complex at the university. There are plans to build more of these high-rise residence halls on the site. Athletic facilities are also planned with a track-and-field and tennis center; a modern gym, including aerobic and strength-training facilities; and a pool.

ACKNOWLEDGMENTS

I would like to thank Rebecca Alssid, Shanyn Arnold, Laura Asci, the Boston Public Library Telephone Reference and Social Sciences Departments, Jeffrey Baumgardner, William Bergmann, Denis Bustin, Kevin Carlton, Ed Carpenter, Peg Clark, Irene Christopher, Michael Ciarlante, David Cobb, Dina Croce, Phyllis Curtin, Sharon Daniels, Joan Dee, Glen Dixon, Sheila Donahue, Vernon Doucette, Jim Eisenberg, Michael Field, Sara Field, Michelle Gagnon, Diane Gallagher, Joseph Garven, Susan Giovino, Marie-Hélène Gold, Edward Gordon, Howard B. Gotlieb, Susan Greendyke, Jack Grinold, Margo Hagopian, Dennis Hart, Holly Hatton, Bert Hirshberg, David Janey, Rena Katz, Katherine Kennedy, Katherine Kominis, Eric Kong, Susan Kong, Brian Kydd, Bruce Kydd, Jacob Kydd, Richard Kydd, Greg Ladd, Joanne Laubner, Albert L'Etoile, Naomi Lomba-Gomes, George K. Makechnie, Wendy Mackey-Kydd, Natalie Jacobson McCracken, Joseph Mercurio, Patricia Mitro, Sean Noel, Robert Oresick, Vita Paladino, Steven Pentek, Rodney Pratt, Brother Rahl, Alexander Rankin, Christopher Reaske, Bachar Saba, Anthony Mitchell Sammarco, Alice Seale, Dianne Schaejbe, David Smollen, Tiffany Spitzer, William Spitzer, Fred Sway, Jessica Theodore, Larry Sawires Yager, Rick Young, Kalman Zabarsky, and Sarah Zenewicz.

Unless otherwise credited, all images are property of Boston University.

BIBLIOGRAPHY

Ault, Warren O. *Boston University, the College of Liberal Arts: 1873–1973.* Boston: Trustees of Boston University, 1973.

Bruce, Robert U. *Bell: Alexander Graham Bell and the Conquest of Solitude.* Boston: Little Brown and Company, 1973.

Kilgore, Kathleen. *Transformations: A History of Boston University.* Boston: Trustees of Boston University, 1991.

Makechnie, George K. *Fourscore Years & Twelve at Home and Boston University.* Boston: Trustees of Boston University, 1999.

———. *70 Stories about Boston University.* Boston: Trustees of Boston University, 1993.

Salzman, Nancy Lurie. *Buildings and Builders, An Architectural History of Boston University.* Boston: Boston University Scholarly Publications, 1985.

Speare, E. Ray. *Interesting Happenings in Boston University's History: 1839 to 1951.* Boston: Boston University Press, 1957.